Aiden - 1...
your I...
from a c...
view. In Belfast, there
is a mural of Bobby
Sands with a quote

'I arose this morning...'

A Biography of Bobby Sands
for Younger Readers

from him: Our revenge
will be the laughter of
our children. I think
basicly Bobby Sands was

adapted by
Denis O'Hearn and Laurence McKeown

illustrated by
Thomas "Dixie" Elliot

a man of peace. Love, Sheila
aunt Sheila
Uncle Harton

First published 2006
by
Beyond the Pale
BTP Publications Ltd
Unit 2.1.2 Conway Mill
5-7 Conway Street
Belfast BT13 2DE

Tel: +44 (0)28 90 438630
Fax: +44 (0)28 90 439707
E-mail: office@btpale.com
Website: http://www.btpale.com

British Library Cataloguing-in-Publication Data.
A catalogue record for this book is available from the British Library.

ISBN 1-900960-31-1

All illustrations copyright © of Thomas "Dixie" Elliot.

Thanks to Gráinne Campbell and Mick Beyers for their advice and support.

About this Book

The title of this book comes from the translation of a poem written in Irish by Bobby Sands while he was in prison. He died in prison on 5th May 1981 after a hunger strike lasting 66 days. This is the poem:

D' éirigh mé ar maidin mar a tháinig an coimheádóir,
Bhuail sé mo dhoras go trom's gan labhairt.
Dhearc mé ar na ballai, 'S shíl mé nach raibh mé beo,
Tchítear nach n-imeoidh an t-iffrean seo go deo.
D'oscail an doras 's níor druideadh é go ciúin,
Ach ba chuma ar bith mar nach raibheamar inár suan.
Chuala mé éan 's ni fhaca mé geal an lae,
Is mian mór liom go raibh me go doimhin foai,
Ca bhfuil mo smaointi ar laethe a chuaigh romhainn,
S cá bhfuil an tsaol a smaoin mé abhí sa domhain,
Ni chluintear mo bhéic, 's ní fheictear mar a rith mo dheor,
Nuair a thigeann ar lá, is feidir ní bheidh mé ann.

I arose this morning as the screw came,
He thumped my door heavily without speaking,
I stared at the walls, and thought I was dead,
It seems that this hell will never depart.
The door opened and it wasn't closed gently,
But it didn't really matter, we weren't asleep.
I heard a bird and yet didn't see the dawn of day,
Would that I were deep in the earth,
Where are my thoughts of days gone by,
And where is the life I once thought was in the world?
My cry is unheard and my tears flowing unseen,
When our day comes I'll probably not be there.

Bobby Sands, Nuair a thigeann ar lá.

The book has been specially adapted for younger readers from Denis O'Hearn's biography of Bobby Sands, *Nothing But an Unfinished Song*, published by Nation Books (New York) and Pluto Press (London) in 2006.

Three people worked on the book. Denis O'Hearn and Laurence McKeown prepared the text. Denis is Professor of Sociology at Queen's University Belfast and at State University New York at Binghamton. Dr Laurence McKeown is a former Irish political prisoner and hunger striker. On leaving prison he studied for a PhD and now works as a playwright and author. Thomas "Dixie" Elliot prepared the drawings that illustrate the text. Dixie is a former Irish political prisoner who shared a cell with Bobby Sands.

Sunday 1st March 1981

I am standing on the threshold of another trembling world. May God have mercy on my soul.

My heart is very sore because I know that I have broken my poor mother's heart, and my home is struck with unbearable anxiety. But I have considered all the arguments and tried every means to avoid what has become the unavoidable: it has been forced upon me and my comrades by four-and-a-half years of stark inhumanity.

I am a political prisoner. I am a political prisoner because I am a casualty of a perennial (constant) war that is being fought between the oppressed Irish people and an alien, oppressive, unwanted regime that refuses to withdraw from our land.

With these words in his diary, Bobby Sands began a hunger strike, refusing to eat food until he and his fellow prisoners gained their rights...or until he died. Just a young man of 26, it was his last big choice to make in a life of choices that most people hopefully never have to make. At eighteen, he'd had to choose whether he should join the Irish Republican Army and take up a gun to fight a system that he felt was unjust. After spending years in prison, he had to choose whether to take up arms again, in full knowledge

7

that it would probably land him back in prison.

Many, many choices. Many moral consequences. Yet, though he made decisions that many people would not agree with, he never took the easy road. And he never regretted the road that he had chosen.

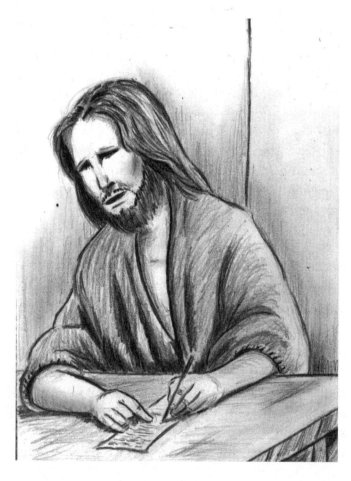

Monday 2nd March 1981

Much to the distaste of the Screws we ended the no-wash protest this morning. We moved to 'B' wing, which was allegedly clean.

We have shown considerable tolerance today. Men are being searched coming back from the toilet. At one point, men were waiting three hours to get out to the toilet, and only four or five got washed, which typifies the eagerness of the Screws to have us off the no-wash. There is a lot of petty vindictiveness from them.

Bobby Sands sat next to the table in his new cell. It was two days since he ate his last bit of food, an orange. How much had changed in those forty-eight hours! He could not remember the last time he had been alone. For years he'd had a cellmate. It was good to have company, but sometimes you got tired of talking about the same old things over and over. It would be peaceful to be by himself for awhile. Still, he would miss having Malachy around.

He was naked and wore a blanket to cover himself. He only wore clothes — the prison uniform — once a month when he got a half-hour visit with his family. And the trousers of that uniform to go to mass on Sundays. That was the only time he met with the other prisoners, apart from Malachy, of course. The priest saying mass

could hardly make himself heard, they talked and laughed so loud.

But other things had changed. For one thing, it had been more than three years since he sat at a table. And the shower! How good it felt to have a shower after all that time, even though the guards made some prisoners wait hours to wash. His skin had burned a little from the soap, even though it was very mild.

The bed was hard to get used to after lying on a foam mattress on the floor all those years. Best of all, he had a newspaper to read, and some letters from his family. There was even a letter from his sister Bernie who he had not seen for several years. Tomorrow he might even get a book to read.

Funny he should be thinking about such little things when he knew he was starting to die. He would never eat again unless they won their demands. Two years ago he thought the prison guards were trying to starve him and his mates. The milk was so watered down it was grey and Joe Watson counted twelve cornflakes for breakfast one morning. Now that he was on hunger strike, the guards were piling heaps of food on his plate. God, it smelled good! But he was surprised that he was not hungrier. It seemed when you believed strong enough in something, things like hunger and pain sort of disappear.

He thought about his family, especially his

mother Rosaleen and father John. It was so hard on them. And the things they would have to endure once he started wasting away. He sometimes wondered whether he had the right to inflict this on them. But then he thought of his comrades and the terrible things they had been through over the past few years. These men meant the world to him, maybe even more than his family. If it took his death to get them out of this hell, well, he hoped his family would understand and be strong.

Understand and be strong. How could he help them be strong? How could he be sure his mother would let him die? Any mother would ask for her son to be fed if he slipped into unconsciousness. How could anybody ask his mother not to do that for him? Yet this was what he was doing. And his biggest fear was not that he would die. He had no fear of death. His biggest fear was that his mother could not let him die.

At least he'd got good news from Father Murphy, old Silvertop, who visited earlier that night. Silvertop told him how his mother spoke to a crowd of his supporters the night before. She was great, he said, really strong. And his sister Marcella too. It gave him heart to have such support. But best not to dwell on these things.

Bobby went over to the back corner of his cell.

He got on his knees and put his head down to the crack by the heating pipes.

'Philip, give us a smoke.'

What a relief it was to have Philip Rooney in the next cell. His big brother Gerard, they all called him Roon, had been one of Bobby's best friends years back. Now it was a comfort to have someone close to talk to.

Rooney went to get tobacco to roll a cigarette for Bobby — one of their few small comforts. The prison guards tried so hard to stop the prisoners getting tobacco, but they always found a way to

smuggle it in. Sometimes they got caught and it meant a period of punishment in the special cell block called the 'boards', because of the concrete block with boards on it for a bed. But most of the time they got the tobacco safely to their cells and everybody who smoked got a cigarette. Even the non-smokers enjoyed it all. It was a small victory over the guards.

Rooney lit the cigarette and passed it into Bobby through the crack. Then he took one for himself and they sat and talked through the pipe. The guards were off the wing for the night so they could relax.

Bobby told Rooney about his childhood in Rathcoole, the huge housing estate where he lived. It was a different childhood from Rooney's. Philip had lived in a crowded inner-city district where the terraced houses were crammed together like dominoes. Rathcoole was a big open estate on the edge of Carnmoney Mountain with big houses and big gardens. All Rooney's neighbours were Catholics, like himself. But most of Bobby's neighbours were Protestants. They called it a 'mixed estate'. Rooney went out his front door into a warren of streets and houses, with hardly a green space to be seen. Bobby went out his front door and up the mountain.

'You know, if things would've been different I'd

have loved to have been an ornithologist', he said.

Bobby had always loved birds, ever since he and his sisters Marcella and Bernadette explored Carnmoney as children. He liked to watch them play and listen to them singing. He learned to identify them. He could tell you all about their habits and which birds liked to fight with the others.

"Well, you never know, Bobby", said Rooney. "Maybe you'll get through this thing. Maybe we'll get out of prison one day and then you can study birds."

"Well, if I get through this, well and good", Bobby replied. But both men knew there was practically no hope.

They lay back against the wall and thought and smoked. Bobby's mind went back to his childhood. How did he get from there to here? How could you get to a point where you were willing to go hungry to help several hundred men win the right to be known as 'political prisoners', to wear their own clothes instead of the denim uniform of a common criminal?

How hopeful he had been back in those days. All the kids played together. Nobody really thought about whether you were Catholic or Protestant. You just played. Bobby sort of remembered that they had to leave their old house at Abbot's Cross.

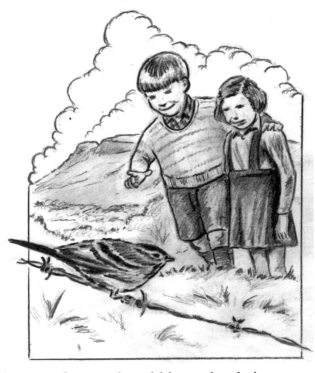

He sort of remembered his mother being upset at something. But he was still pretty innocent. It was a few years later that Rosaleen told him and his sisters how they had been driven from the house because she was a Catholic. They would learn later how the woman next door taunted their mother whenever their father was away at work in the bakery.

He recalled being with his sisters and other kids from the neighbourhood. They were camping. The

others built a lean-to from some brush while Bobby started a fire. They roasted spuds and wondered how long the summer would last. Once they strung a line between two trees and Bobby slid down it, like the guys in the adventure movies. But he hit a knot in the line and fell and hurt his arms. They visited the big rock on the other side of the mountain and flushed birds out of the prickly gorse bushes. There was always plenty to do.

School was the only place where his friends were all Catholic. Bobby never liked school much. Not that he disliked it. Stella Maris was a good school, made of clean new brick. The teachers were pretty nice, not mean and violent like you always heard about the Christian Brothers. Sometimes he heard stories from his cousins about the bad treatment the kids got in other schools. But neither Bobby nor his friends were that interested in studying or reading. That was something for his sister Marcella, not for him.

'Intelligent but lazy.' That's how Bobby's friend Dessie described him. But there had been one great thing about school days — football. It was then that Bobby and his best mate Tommy joined their first organised football club and dreamed of being stars. Tommy was the best, of course. Years later he even got a tryout with a team in the Premier League. But Bobby wasn't bad; left half,

a good tackler, not a scorer. How he loved his football back then. He even dreamed of playing for Aston Villa.

There were some great guys on the team. Willie, Raymond, Geordie. All Protestants. So were Terry and Michael, but later they changed. Not at first, though. At first they all played together. Nobody asked if you were a Catholic or a Protestant. The only thing that mattered was football. If you could play, you were on the team.

School meant other sports, too. Bobby wasn't a bad swimmer. Even won some medals. But it was running that he loved. Nothing like running over the hills, through the gorse, the rain beating on your face and your feet squelching in the mud. It meant freedom. Just like the lark. His grandfather once told him never to kill a lark because that was the bird that represented freedom. And when he and Tommy went running through the bushes and flushed a lark, Bobby felt like he knew what it was to be free.

Sitting in his prison cell now he sometimes wondered if he had really felt that way back then, or if it was something he had made up in his mind after he lost his freedom. Maybe he took it all for granted back then. He remembered the story he told the other lads on the wing, about the Frenchman on death row who looked at the cherry blossoms. He had seen them every day of every

spring. There were cherry trees all around his house. But now he knew he would never see them again. It was only when you lost something that you really knew how beautiful it was.

Maybe it was like that with the lark. Bobby knew that he would never run through the hills again, never flush the lark or the thrush. And now he knew what the lark really meant to him. He would miss it.

Bobby was thirteen or fourteen when everything started to change. He couldn't remember exactly when, but some of his mates didn't want him or his sisters to come round to their houses anymore. Bobby was pretty confused at first. There had always been a period around the 12th July when things were uneasy in Rathcoole but now his circle of friends was breaking apart all around him. The only thing that was staying together was the centre of his life: football. Despite the tensions that were breaking out in society all around them, the lads, Protestant and Catholic kept playing for Stella Maris.

Bobby started hearing about a man called Paisley, who was making speeches about how the Irish were traitors and papists who were trying to change the Protestant way of life. Bobby also heard about a new group called the Ulster Volunteer Force that started killing people because they were Catholics. Everybody called them the UVF.

By the time Bobby was fifteen, these things started to get really bad. Bobby remembered watching the news on television and you could see the changes. People were marching in the streets, carrying signs and demanding something they called their 'civil rights'. The police, known as the

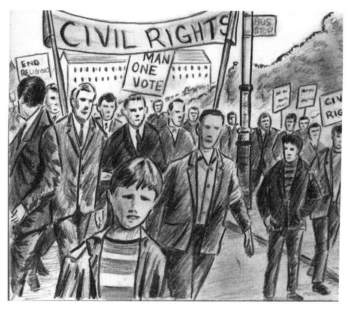

Royal Ulster Constabulary or RUC (everything was turning to alphabet soup) did not seem to like these people and he watched them bashing their batons over the heads of the marchers. Blood was dripping down their faces and gas was in the air.

Bobby's mother Rosaleen got mad when she saw these things and she began to explain what was

going on. She said she had been through all of this back in the 1930s, when she was growing up. Now she was upset to see it happening again. The marchers were not all Catholics, but they were marching because they said that a lot of Catholics had a hard time getting houses or jobs. Lots of them were not allowed to vote in elections. They were protesting against something they called discrimination. So many new words to learn.

Bobby knew one thing. He watched the police hitting people over the head and he did not like it. All of his life, he had been watching TV programmes and the police were the good guys. He and his friends imitated them in their games. Now here they were beating people, and his mother said that it was just because the people Catholics. Bobby had to figure out what it really meant to be a good guy or a bad guy.

One event really stuck out in his mind. It was January and a lot of students from the university were marching across the island, from Belfast to Derry, to protest for civil rights. They nearly got to Derry but when they were at a bridge outside of town a big gang of men attacked them and hurt some of them pretty badly. It seemed like the police were helping the men attack the students. Bobby was really getting angry. It wasn't happening to him personally, but he knew

something was happening to people like him.

Soon, things got out of hand and the government sent in the British army. At first, a lot of the Catholics seemed to be quite happy about this because they thought that the army would protect them from the gangs of men and the police. But things just seemed to get worse. Bobby's parents and his friends started saying that the army just stood by while gangs of Protestants invaded Catholic areas and burned down whole streets.

A few people started asking why somebody was not defending these people who were under attack. Some started talking about a group called the IRA (more alphabet soup). This was the Irish Republican Army and people were saying that the IRA would defend Catholics from the gangs.

The trouble moved from the TV screen and into Bobby's life. In the summer after he had just turned fifteen, Stella Maris, the centre of his universe, began to fall apart. Terry and Michael left the club that summer and they never came back. Terry said that his thoughts were "just going away from Catholics". He saw the civil rights campaigners marching in the streets and to him they were rebels who had to be put in their place and it was young Protestants like him who would have to do it.

Terry and some of the others joined a new gang in Rathcoole. They called it a tartan gang because

everyone wore a tartan scarf. Their name was terrifying. They were the Kai, which stood for 'Kill All Irish'. More alphabet soup. The Kai hung around the shops, intimidating people who they didn't like. Mostly they intimidated Catholics. This was especially bad news for Bobby and his friend Tommy. Whenever they came home from the town they had to find back routes to avoid the Kai boys. Otherwise they would get beat up.

Bobby said it was lucky they were fast runners because many a time they had to run to get away from the Kai. Sometimes they made it home but often they had to run to the nearest friendly door. Bobby could remember him and Tommy banging on the McGinn's door, out of breath and hoping to get in before the gang caught up to them.

One night, Bobby didn't make it to a friendly door. He was coming home by the way he thought safest when he ran into the police. They told him there was trouble up ahead. He'd have to go the other way. Bobby's heart sank. He knew the Kai boys hung out in that direction but there was nothing he could do. On the alley behind his house he ran into them. One asked Bobby for a light for his cigarette. When Bobby paused another stabbed him with a small knife. Bobby managed to run and jump over the back wall of his house and get away from them.

But now he had a new worry. He didn't want his

mother to know about the trouble. So Bobby went straight to his sister Marcella who took his bloody shirt to wash it. Bobby put on a clean shirt and sneaked back out the door before his mother could see him. He went round to a friend who knew some first aid and got patched up.

The Kai sang songs to taunt the Catholics.

We come from the 'coole and we hate the micks,
We beat their bollix in with our sticks,
We'll fight the Fenians 'til we die,
We are the Rathcoole Kai-ai.

If you go to the valley any night,
You'll see the boys looking for a fight,
We fight with bottles and we fight with sticks,
We're just a bunch of lunatics.

Not all Protestants were bad, though. A lot of them were disgusted by the antics of the tartan gangs. Bobby was encouraged when Raymond and Willie and Geordie came back to play football at the end of the summer. But now things were too dangerous to keep playing at Stella Maris. The club disbanded and its members moved to the Star of the Sea football club just outside of Rathcoole…

A cell door slammed and shook Bobby out of his daydream. He began to read some of the letters he had received. It was quite a luxury to get so many

letters. Since he'd arrived in the H-Blocks three and a half years ago, he only got one letter a month. That wasn't counting the letters he smuggled in whenever he got a visit, of course.

He needed a letter just now to cheer him up from the bad news he had heard earlier. His friend Tomboy down the corridor from him had shouted up to say his father had just died. Bobby was terribly annoyed and upset with the news. He always liked Tomboy's da. He had a letter from Séanna Walsh, his other great friend besides Tomboy. Séanna was in prison, too, over in H5. Then, a letter from his mother, Rosaleen, finally raised his spirits.

"She has regained her fighting spirit", Bobby told himself. "I am happy now."

Bobby thought about writing a poem but he was too tired now. He put down his ballpoint pen refill and gathered up the bits of toilet paper on which he was writing his diary. He would have to be careful that the guards didn't see them or they would take them away and maybe take him to the punishment cells. That would be bad. Then he'd lose his bed and have to sleep on the hard boards. He hid the writing materials and lay down for his first night's sleep in a real bed.

Tuesday 3rd March 1981

I'm feeling exceptionally well today. (It's only the third day, I know, but all the same I'm feeling great.) I had a visit this morning with two reporters, David Beresford of The Guardian *and Brendan O Cathaoir of* The Irish Times. *Couldn't quite get my flow of thoughts together. I could have said more in a better fashion.*

Bobby awoke feeling exceptionally well. He was due a visit with two reporters. One was from an Irish newspaper, the other from an English one. They were both important newspapers and telling his story to them would be a big boost for his protest.

To go on his visit, Bobby first had to go to the cell they called the 'big cell', to put on the prison uniform. Then the guards searched him and took him to the visiting room.

Bobby introduced himself to the reporters. Then he spent thirty minutes trying to explain why he was on hunger strike. He said that he expected to die. He was doing it for his comrades, the other prisoners, so that they would not have to continue to endure the horrible things they had gone through for the past four years. One of the reporters asked him how he could go against the Bishop who had requested him to stop his hunger strike. Bobby

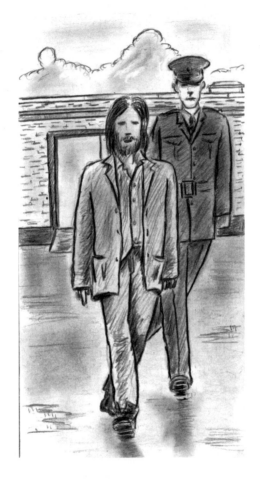

said he only answered to a higher authority than the Bishop.

'If I die, God will understand', he told them.

Back in his cell, Bobby thought about decisions. It was good to be able to make your own decisions. Even if you made the wrong decision, it

was yours and you could live with it. The worst thing was when someone else was making your decisions for you. The worst thing was when you were not in control of your own life.

Bobby put down his pen and his diary and sat on the bed to read. He had got some newspapers and a book earlier in the day. A real book! Another luxury after all those years. Funny, he was never much of a student. He never went in much for books as a child or even as a teenager. But after he went to jail the first time he learned that a book was about the best thing there was. Friends and books. Books could even improve a friendship because a good book gave you something to talk about with your friends. If they read the book, you could discuss it and then you appreciated the book even more because it became a shared part of your friendship.

It was a real change in his life, that first spell in prison. Not many people would think of prison as a good thing. But for Bobby, it was his university. He had left school early to go to technical college to train as a mechanic. University was out of the question. Maybe for Marcella; she was clever. For Bobby, prison was the first time he really got to think about his life and what he was doing. Until then, he just reacted to the things around him. Things that made him angry.

First it was the Kai. It was bad enough when he

and Tommy had to avoid them. But later on things got a lot worse. Some adults joined them and started what they called vigilantes. Vigilantes were people who went onto the streets and tried to keep other people off the streets. Except in this case, it was Protestants trying to keep Catholics off the streets.

Pretty soon, the vigilantes started to drive people out of their houses just because they were Catholics. Someone would come around at night and put a mark on a house. Then the next night the whole gang came around. It would start with a bin or a brick through the window. Sometimes they would fire a gun through the window. This usually scared the family enough that they moved out of the house. Next day a new family moved in. The new family was always Protestant.

One time, a man came up to a little girl and gave her an envelope to take to her parents. When they opened it up it was a bullet. They moved out after that.

Some adults started talking about setting up some kind of a citizens' defence committee. If they got together, they said, maybe they could look after each other and go to the police together to get protection. But Bobby started hearing stories about how the police were friendly with the vigilantes. One time a newspaper carried an article

where a policeman said that the vigilantes were a good thing because they were keeping the streets safe. The local politicians said the same thing.

'I don't feel very safe', thought Bobby.

Another policeman said that it was all the Catholics' fault. They just wanted to move house so they made up all these stories about how the vigilantes were trying to scare them.

Bobby always said it wasn't right to let somebody drive you out of your home so leaving was not a choice for him. And he didn't think these citizens' defence committees could do much good. The police and the politicians had already made it clear whose side they were on and it was not the side of the Catholics who were being driven out of Rathcoole.

There was one other possibility. Bobby had friends from outside Rathcoole who told him people in other areas were joining the Irish Republican Army, the IRA. They had guns and they were trying to protect people from the vigilantes and the police. But that was not enough. The IRA believed that Irish people would have to fight for their freedom. The police and the British army were there to keep this unfair society in place so the IRA would fight to drive out the British army.

To Bobby, this made sense. The only way to

fight this evil thing was to take it head on. As a child, he had never shrunk from a fight. If he saw someone hitting his sisters he dived right in to defend them, even if it was some really big guy and he was sure to get a beating. Bobby didn't waste any time. He went up to a fellow who he had heard was in the IRA.

"Are you in the IRA?" he asked. "Because I'd like to join."

The man tried to talk him out of it. He said that Rathcoole was a dangerous place. The vigilantes and the Kai gangs were too strong and there was no IRA there to protect people like Bobby. If the vigilantes found out about him he would be on his own.

Well, Bobby had always been stubborn and he was never one to run from a fight. So he said that he wanted to join the IRA anyway. He had friends, too, who wanted to join. Finally he convinced the man and the IRA agreed he could set up what they called an 'auxiliary unit'. The auxiliaries did not get directly involved in military attacks. Bobby and his young comrades were trained to use guns and sometimes they went out and acted as lookouts for the men who were full members of the IRA. These men called themselves 'volunteers'.

The man had been right. The IRA could not protect Bobby, nor could they protect any other

families in Rathcoole. Bobby was just seventeen when things got totally out of hand. More and more families were being driven out of Rathcoole. One day the Kai and the vigilantes took over all the roads in and out of the estate. They put cars and buses across the roads and nobody could move without their permission. A flute band marched up and down past Bobby's house playing sectarian songs and shouting 'taigs out'. All the Catholic families stayed in their houses, afraid of what could happen once night fell.

Bobby's parents just wanted to get out. They were sure they would lose the house that night. But Bobby, as usual, said it was not right that anyone should be able to drive you from your home. Besides, the vigilantes would never let them out past their roadblocks. He switched off the lights and sat up all night on the stairs with Marcella, facing the front door of their house. Bobby had a knife and Marcella had the pepper pot. If the gangs tried to break in, Marcella would throw pepper in their faces and Bobby would get them with the knife.

Desperate people make desperate plans.

Luckily, no one came that night. But it wasn't long before they did come. One day Bobby's sister Bernadette saw a local woman standing with a couple she had never seen. The woman was

pointing at their house. Bernadette was afraid that it meant trouble.

A week later, the family was sitting watching TV when a bin came crashing through the window. Then some bricks and stones and some gunshots.

Rosaleen went to the Housing Executive the next morning and told them about the attack on their house. The woman in the office told her to go to another estate called Twinbrook. She said that all the Catholics were moving there. It was a safe area. "Just find a house and move in", she said to Rosaleen, "then come back and I'll register the house in your name."

So that's what Rosaleen did. Twinbrook was miles away, across to the west of Belfast. But they had to go somewhere safe. She found a nice house, across from a big expanse of green fields and the family moved in the next day.

Bobby's remaining Protestant friends on the Star of the Sea football team couldn't do anything to help. Raymond had tried to help one family weeks earlier but he gave up when he realised that the mob would just come back the next night or the next night. Geordie never even tried to stop the mobs. He said it would just be a waste of time.

One by one, all of Bobby's friends left Rathcoole. Some of them went to Twinbrook. His girlfriend Geraldine and her family went to Unity

Flats. His best friend Tommy got his football tryout with a big English team but it never worked out and he and his family had to move to Ardoyne.

Belfast was splitting up into 'Protestant areas' and 'Catholic areas'. Bobby had played football and run cross country with boys of both religions all of his life. Until recently, they had all played together on the streets of Rathcoole and up Carnmoney mountain. But then the Kai and the vigilantes came and now those days were over.

Bobby had choices about some things but about other things he had no choice. He could not simply live where he wanted to or play with whomever he

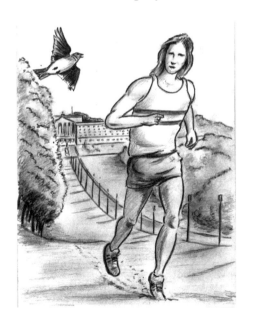

wanted because he was known as a Catholic. He had a job for a time as an apprentice in a bus factory. But the other men in the factory told him that he was not welcome. One day a man pulled a gun on him and told him that if he did not leave the factory, "This is what you'll get". Then the boss told Bobby he would have to go. All because he was a Catholic.

In Ireland they call this attitude sectarianism but it is basically the same as racism. In South Africa at the time, blacks and Indians were banned from living in certain areas or working at certain jobs. All over the United States the same thing was happening to Afro-Americans, American Indians, and Latinos (people from Spanish-speaking places). Like these other people, Catholics in Belfast found it harder to get a job or a house. For a long time, they didn't even have a vote. They often felt like the police harassed them. There were a lot of things about their lives where they felt like they had no choices.

But they did have choices about what to do about these things. The civil rights marchers tried peaceful protests. They marched through the streets with placards and often sat down and blocked traffic. But they often got their heads cracked by a police baton no matter how peaceful they were. Like the students Bobby watched on

TV being beaten on that bridge outside of Derry.

Some people stayed peaceful, no matter what. But the British army came in and after some of the awful things they did to people more and more Catholics (and a few Protestants) decided that the only way they would ever win their freedom was by taking a gun and fighting for it.

Bobby felt this way. He made his choice because of the things he experienced in Rathcoole. But when his family were driven out of Rathcoole to Twinbrook he found other reasons to stay involved in the IRA. If anything, he became more committed to the IRA and its strategy of armed struggle.

Twinbrook was different from Rathcoole in lots of ways. Life was a lot harder. Most of the houses were not even finished yet so people had to scrounge for basic things like water and something to cover their glassless windows with. Many of them didn't have a toilet so they had to use a bucket and empty it out across the fields. Most of the people around the world live like this but it was not usual in Belfast. The Sands family were lucky because their house was finished. So they helped out the other less-fortunate families. Bobby's mother and his sisters took flasks of hot water and milk to families of maybe eight or ten people living in unfinished flats.

There weren't many public services in Twinbrook. No doctors, no libraries, no supermarkets, no places of entertainment, not even a pub. The church was a wooden hut. The local school was a wooden hut. There was a small shop, a chippie and a post office. Only a few buses went to Belfast and back.

But at least there were no gangs of vigilantes wandering around waiting to attack people because of their religion. The people of Twinbrook could walk around day or night without fear of being bothered. Except for one thing. The British army.

The British army kept coming into the estate. And when they did, they would often take all of the young boys and even the old men and line them up at the shops, spread-eagled against the wall. Sometimes they kept them there for hours. They would shout at them and sometimes hit them with their rifle butts.

Young people like Bobby were angered by the indignity of it all. Some of them wanted to fight back with their bare hands. One time Bobby and his friend Jimmy were spread-eagled against the wall at the shops. The British soldiers kept going up and down behind them shouting at them and telling them to keep quiet. One of them hit Jimmy in the back of the head and Jimmy got so angry that

he turned to Bobby and whispered that he wanted to fight the soldier right then and there. "Don't be stupid, they'll kill you", said Bobby, under his breath. Then he added, "there is a better way."

What Bobby meant by a 'better way' was the IRA. He had been angry at the gangs and the police in Rathcoole because of their violence against him and his friends. They drove his family out of their home. But in a way this was even worse. The British army were attacking their dignity. Treating old men as if they were not even humans. This experience convinced Bobby that he would stay in the IRA until jail, death, or freedom. But the British army were so powerful that you could not just fight them straight out. The IRA said that you had to fight them on your own terms — as a guerrilla army.

Years later, Bobby could see how simplistic he had been. He learned a lot after those early days. Back then, as his friend Jimmy said, they were just angry rebels and not revolutionaries. It was only later that they became revolutionaries. A rebel is just against something and wants to get rid of it. A revolutionary wants to build a better kind of society in its place.

Bobby's activities soon got him into prison. He was not six months in Twinbrook before a woman who was hiding guns for him turned him into the

British army. She was probably scared. Bobby heard later that the British paid her money for the information and she used it to move to England.

Bobby was taken to the police station and questioned for hours. He admitted some of the things the police asked him about. They included things like possessing guns and being a member of the IRA. Bobby said later that the police beat him. It's possible. They were beating a lot of people in those days. He signed some statements admitting what he had done. But despite pressure from the police he refused to talk about anyone else who was with him. The police took him to court and charged him. Then they took him to prison.

Prison was a completely different experience than anything Bobby had known. Long Kesh prison camp was like something out of an old black and white war movie, a prison camp complete with soldiers and big German dogs patrolling the perimeter. High walls and rolls and rolls of barbed wire surrounded Long Kesh. On the inside, more barbed wire and a bunch of fenced in areas that the authorities called compounds. The prisoners called them cages. They were like cages because they were surrounded by wire and the men were locked in.

The prisoners lived in World-War-II-style Nissen huts. There were four huts in each cage,

along with a big wooden building that had washrooms and toilets. About a hundred men lived in each cage. Each hut had beds running down either side. The wind blew in through the draughty windows and the rain dripped through the leaky roof.

It was a different kind of living from anything

Bobby had ever experienced. He had never lived together with so many men, all eating together and working and playing together. They all had to cooperate. Everyone had to do his job or things could fall apart. But this also meant that everyone came to depend on each other. They got closer. They became comrades.

That's what Bobby needed soon after he went to prison — some comrades. He found out that his girlfriend, Geraldine, was pregnant. They decided to get married. But how can you be a husband and a father from inside prison? Or a wife and a mother from inside prison? It's a problem that a lot of people have had to face. It's a hard thing to face. But Bobby also knew that he made a choice about how to live his life and that choice sometimes meant jail. No use crying over it. He married Geraldine. The next week he went to trial. He was found guilty and the judge sent him back to prison for five years.

Different people react to prison differently. Some like to put their time in playing cards or messing around. Some like physical activities, from running to lifting weights. Some get lazy and sleep a lot. Nearly everybody gets a little depressed, especially if they have a family on the outside. When Geraldine gave birth to a boy they named him Gerard. Each time Bobby had a

visit he waited impatiently to see his new son, hoping against hope that he could somehow make a relationship with him in half-hour meetings.

The most amazing thing about Bobby was how he used his opportunities. Where many of us would see a problem he would see opportunity. It was like he recognised that through solving the problem he would become a stronger and better person. Prison provided time. It also provided all sorts of people with different talents and ideas. Bobby figured that with all that time and all those talents around him he could learn things. He could learn to understand new things and he could learn to do things that he enjoyed. And that is how he spent his time in prison.

There was a man called Rab in Bobby's cage who was a great guitar player. He had a stammer when he talked but not when he sang. Bobby loved music, ever since he went to dances back in Rathcoole. He loved the kind of music you dance to and the kind you sing along to. Rock and roll, folk music, Irish traditional music. He loved all kinds of music. So he asked Rab to teach him guitar. Why not? He had plenty of time. So during his free time, while the other prisoners were playing cards or something else they had to endure Bobby strumming on his

guitar. Plunk, plunk, plank! It was pretty annoying for some time but then he began to learn more chords. He memorised lots and lots of songs. And pretty soon it was Bobby who was always at the middle of a sing-song or a concert in the cage. Funny, but if he hadn't got caught and sent to jail he probably never would have learned the guitar.

Then he learned the Irish language. An older prisoner used to come round to the cage to check on all the prisoners to see that they had everything they needed and that the guards were treating them all right. As the man went round he taught Irish. Bobby and Tomboy and Séanna worked hard at the language. As he learned, Bobby thought back to his time at school in Rathcoole. He started to think about how he had wasted his opportunities back then. Oh, it was not all his fault. The school never taught them the things that interested him now — like Irish language and Irish history. But there was no use sitting around regretting lost opportunities. Instead, Bobby grabbed onto his new opportunities and he and his mates taught each other the things they had never learned in school. They began to read about history and politics. They read books that showed how men with power and money used it against the powerless and the poor. They also read books

that showed how the powerless can rise up against the powerful and take back control of their lives. As they learned, they began to feel like they had a new power. They were in control of their minds and they were in control of their lives in prison. It got easier to 'do time'.

One story that really impacted upon Bobby was that of a young doctor called Che Guevara. Che was from Argentina but he travelled around South America on a motorcycle. As he went around he saw the bad things that most people endured. He met miners who were treated like slaves. He treated poor people who had leprosy, a disease that wastes away your body. Nobody would go near those with leprosy because they were afraid of catching the disease too. But Che and his best friend lived among them and treated them like human beings.

As Che Guevara went around South America he discovered that it wasn't medicine that the people needed. What they really needed was justice and dignity. So Che joined with a Cuban man, Fidel Castro, and they went on a boat from Mexico to free the people of Cuba. For months they lived in the mountains of Cuba, recruiting the poor people to their guerrilla army. Eventually, they led a revolution and tried to build a better society.

Bobby was excited when he read about Che Guevara. And he read books by a priest from Colombia called Camilo Torres who saw injustice in his country and decided that it was not bibles that the people needed but justice and dignity. He was a priest, but he took up a gun and led his people in a fight for freedom.

There were others. From all over the world. From South America, Africa and Asia. He read about how the Vietnamese people in Asia were defending themselves against the US army. And there were even revolutionaries in the United States. Afro-Americans like George Jackson who

fought for the rights of his fellow prisoners and was shot down for doing it. Native American Indians like Geronimo, the brave Apache warrior who led his people against the white settlers who were taking everything from them. Bobby could identify with these people. Was he too not in prison because of his beliefs? His people, too had been fighting invaders for centuries, people who had taken their lands and even their language.

When Bobby was not studying he was walking around the cage with his mates, always anti-clockwise, discussing the things that they were learning about other struggles. When he was not strumming his guitar or learning new songs Bobby was reading books and taking down notes of all the most important points. He would lie on his bed, with his book in his right hand and a pen in his left writing quotes on the wall from his latest favourite book.

Bobby was becoming a revolutionary. He was beginning to think about why he was in the IRA. He started thinking that it was not just because he was angry at the Kai gangs or the police or the British army. Now, he began to think that the reason to be in the IRA was to try and build a better world. It was not enough to knock down injustices. You had to put something better in their place like Che Guevara did in Cuba.

Bobby had been in prison for about two years when they moved Gerry Adams into his cage. Gerry had never been convicted of anything He was sent into prison without trial because the authorities were afraid of the influence he had in his community. They put a lot of people in prison without trial. It was called internment. Like a lot of others Gerry Adams was not happy about being put in prison without even being accused of anything. So he tried to escape. His problem was that he was not very good at it. The prison guards caught him and they sent him to his first trial: for trying to escape from prison, even though nobody could explain why he was in prison in the first place!

Gerry Adams was very intelligent. He had read a lot of Irish history and he knew a lot about Irish revolutionaries. He knew about men and women like James Connolly and Constance Markiewicz, who fought for Irish freedom in 1916. He also knew about other Irish people like Liam Mellowes who wrote about building a new kind of society in Ireland. Adams began to teach prisoners like Bobby some of the ideas that people like Mellowes had. To Bobby, a lot of it sounded like the things he had been reading about from Africa and South America. Gerry Adams said that it was okay to learn about these people in other places but there was also a lot to learn from Irish revolutionaries.

Bobby's favourite topic that came out of these discussions was a thing called people's councils. It was an idea from Liam Mellowes but it also looked a lot like what Che Guevara had been doing in the jungles of Cuba. The idea of people's councils was that the people in a community would take power for themselves. They would run their own neighbourhoods, supply the things that

they needed and govern themselves. It would be democratic because all of the people could get involved in making decisions about the things that mattered to them. If they needed a bus system, they would figure out how to do it. In fact, it would be a lot more democratic than electing people to go off to some parliament far away where they just forget you and your needs.

This was attractive to Bobby because people in areas like Twinbrook felt that the government was not doing much for them. He remembered how the people wanted different services but they could never get them. The government was far away from them. It wasn't even in Ireland but in England. Those guys didn't care about people in a place like Twinbrook. The only government representatives Bobby could remember were the soldiers who lined him up against the wall. Best of all, if you came up with a plan where the people could run their own lives, you were not just working against something, you were also working to create something new and better.

Bobby kept notes from all the things they read and discussed about people's councils. He put it all in a notebook and left it lying around so that other prisoners could read it and discuss the ideas in it.

About this time, Gerry Adams did another thing that had a big impact on Bobby. He started taking

all the ideas from their discussions and writing them up into newspaper articles. Then he smuggled the articles out of prison so that other people could learn from their discussions, too. His first article was about sectarianism. There was a lot of it going on those days. Not just Protestants attacking Catholics but also Catholics fighting back. Adams figured that the British government encouraged this kind of hatred and fighting because it kept everybody's minds off the bad things the government was doing. Adams said that everybody, especially the people in the IRA, should stop fighting Protestants and should realise that the British army and the police were the real enemy.

Bobby watched Adams like a hawk and he began to think that he would also like to start writing things that would make people think. He could write about people's councils. Or he could write about the Irish language and how important it was that people should learn it and use it in their everyday lives. Most of all, Bobby began to see that the best way to get through to people was not by writing too seriously but instead by writing stories that had a message to them. From that time on, writing became an important part of his life.

Wednesday 4th March 1981

*F**r Murphy was in tonight. I have not felt too bad today, although I notice the energy beginning to drain. But it is quite early yet. I got showered today and had my hair cut, which made me feel quite good.*

It was Bobby's fourth day without food. He didn't feel too bad but he began to notice that his energy was beginning to drain. Each day brought new experiences, or old ones that he had not been able to do since ending up back in prison. He got his hair cut and his beard shaved. It made him feel quite good and the other prisoners joked that he looked ten years younger.

'I feel twenty years older', Bobby replied.

It's funny sometimes how we take things for granted, small things like getting a haircut. Bobby had not had a shave or a haircut for over three years. So this small thing for most of us became a big thing for him. It was a kind of luxury. He began to think about how some people had lots of things and others have to go without. He and his comrades had gone without clothes and haircuts and books for a few years. But lots of people around the world live in poverty their whole lives. They always go without. Like the poor people in South America, who were fighting for their rights

just like Che Guevara did. There were people in a small country called El Salvador who were fighting for their rights. All they wanted was to control their lives, to have a bit of land, and some peace so that they could grow crops to feed their families. But the big governments like the British and the US had other ideas.

'They covet other nations' resources', said Bobby.

He was thinking about these things because there was an article in the newspaper about how the new US President, a former Hollywood actor called Ronald Reagan, and the British Prime Minister Margaret Thatcher, got together and announced that they were going to step up their fight against the people in El Salvador.

'They want to steal what they haven't got and to do so (as the future may unfortunately prove) they will murder oppressed people and deny them their sovereignty as nations,' Bobby wrote in his diary after he read the article.

Bobby had something else today that he hadn't had for years. Only this time it wasn't a luxury because he couldn't use it. The guards brought jam to him with his tea. They hadn't brought such a luxury in a long, long time. Bobby knew that they were only doing it to taunt him, because they knew that he was on hunger strike and he could

not eat the jam anyway.

He thought back to how this had all started, when he was in jail before, in the cages. He remembered how one day he and Tomboy had climbed up on top of their hut to look around. They were building a new high wall around the camp. Bobby and Tomboy could just see how the cranes were lowering concrete blocks into place. They were building a new prison right next to the cages. Tomboy said he pitied the fellows that would be going into the new prison. It was a different kind from what they were in. It was a group of one-storey buildings, each built in the shape of an H. 'H-Blocks' they would call them. Instead of huts, they had cells. That meant the guards could lock you into a cell, maybe by yourself or maybe with a mate. But they would have total control over you. Neither Bobby nor Tomboy liked the sound of that.

It soon became clear that the H-Blocks were meant for people like Bobby. The head of the British government in Ireland announced that he was taking away their status as political prisoners (he called it 'Special Category Status'). From then on, any member of the IRA who was put in jail would be treated like an ordinary criminal. They would have to wear a prison uniform. They would have to work in prison workshops. And worst of all they would not be allowed to associate freely

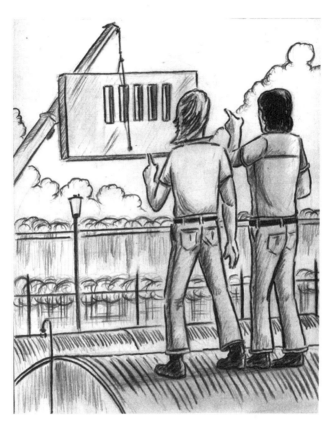

with each other like they could do in the cages. Instead, they would be locked away in cells.

It was Kieran Nugent who they first put in prison, and tried to force him to wear a uniform.

'The only way you'll get me to wear that is to nail it on my back', Nugent told them. Bobby liked that. It was a nice turn of phrase, something that people would remember.

Thursday 5th March 1981

I'm saying prayers — crawler! (and a last minute one, some would say). But I believe in God, and I'll be presumptuous and say he and I are getting on well this weather.

The day didn't start out too well for Bobby. He got word that his father had taken ill and was sent to hospital. "No matter what, I must continue", he thought. Then, he had a toothache. He was getting to the point where any little physical change began to worry him. Thankfully, the toothache was soon gone.

He spent some time reading his new book, the first he'd had in several years. It was a book of Rudyard Kipling's short stories, with some poems at the beginning. Bobby liked one that went like this:

The earth gave up her dead that tide,
Into our camp he came,
And said his say, and went his way,
And left our hearts aflame.
Keep tally on the gun butt score,
The vengeance we must take,
When God shall bring full reckoning,
For our dead comrade's sake.

'I hope not', he said to himself, thinking that Kipling's sentiments about 'dead comrades' hit a bit too close to home. Strange, that he could keep

his sense of humour and laugh about such things. It was as if once you came to terms with death it began to lose its ability to scare you.

But Bobby still had hope. "I have hope, indeed", he wrote later that night in his diary. "All men must have hope and never lose heart. But my hope lies in the ultimate victory for my poor people. Is there any hope greater than that?"

Bobby sat and wrote his day's diary that night. For the first time he began thinking about food. He didn't mind the fact that the prison guards were sticking big plates of food in front of him but he had a craving for brown wholemeal bread, butter, Dutch cheese and honey. He started joking with himself about how he'd get a big feed of his favourite foods when he got up to heaven. Then he was struck by the awful thought that maybe they didn't have food in heaven.

His final thoughts that night were personal ones. The March winds were getting angry and it reminded him that it would be his twenty-seventh birthday in four days, on Monday.

Bobby put away his writing materials and began to think of another birthday, five years before. It was after he and Tomboy sat watching the big cranes building the H-Blocks. The British government announced that they would let a lot of prisoners out of jail early. Bobby was one of them.

So, too, were Tomboy and Séanna. Bobby had just turned twenty-two, had spent the last three years and more in prison and was now on his way back to Twinbrook.

Things were different in his old home area. He had changed, as well. He was not the angry young man who would do anything to fight the British army. Now, he thought more about what he was doing and why he was doing it. He was not just interested in driving the British and the police out of Twinbrook and other places like Twinbrook. No, now he was interested in building something new among his neighbours. He wanted to get them involved in running their own lives, to give them a sense of ownership over their lives. In jail he had read about people and discussed things and now he felt that a few committed people could make a difference for the better in their community. It was his chance to try things out.

Like everything else he did, Bobby jumped into his new life with energy. He needed to. He had a family he had to get to know after all of those years in prison. He also wanted to start working on his ideas about "people's councils", where the people would start running their own lives. Not only that, he also rejoined the IRA. There it was again, another of those hard choices. He could easily have decided just to do his political work

and to hang out with his family. But Bobby was not someone who could ask other people to do something that he wouldn't do. He still believed that the only way the people could build a new society in Ireland was to get rid of the British army and the British government. And the only way to get rid of them was to fight them. So he rejoined the IRA. Maybe it would have been braver not to join them and to try to do other things. Who knows? The bottom line was simply that Bobby would not let other people do his fighting for him. He felt that the IRA was involved in a just war, for a good cause, so he had to go back.

Most of the time, however, he spent doing non-violent things. He tried his best to find time to be with his family and especially to get to know his son Gerard. But Geraldine had to work hard to earn money so that the family could survive. And Bobby was working overtime organising the people in the community. One of the first things he did was to call together some people from the area and talk to them about setting up some projects. They talked about the local tenants association. It had some important resources, like a local hall where they could hold different kinds of events. Bobby said that they should become involved in the association. The ones who were leading it now

were not using the hall much and maybe they could do better.

Bobby and a couple of others organised themselves and went out into the community looking for support. Soon they gathered enough votes to get people that would actually do something onto the committee of the tenants association. Bobby led them. He organised all kinds of events. There was a dance for older people and a disco for young people. During the day there were special events for retired people. And Bobby's favourite activities were the Irish classes where he was the teacher, and the folk nights where he sang songs and acted as Master of Ceremonies.

Then he decided to start a newspaper. He called it "Liberty". At first, Bobby wrote most of the articles. They were about things that happened in Twinbrook, things the police were doing on the people or projects that needed to be done. But he believed in giving power to as many people as possible so he encouraged others to write articles as well. Soon, several of the young people from Twinbrook were writing for the paper and even more people were delivering it door to door.

Twinbrook had a lot of problems and very few resources to solve them. So Bobby organised the people who were becoming involved in his

projects and got them to provide things that the people needed — like transport. There were hardly any buses coming in and out of Twinbrook but people needed to get into town. Bobby talked to the local co-operative taxi service, the 'black taxis', and he persuaded them to start driving to Twinbrook more often. That way people from the area could go to other places that had more shops and services, to get the things they needed.

People who lived in Twinbrook started to notice Bobby a lot more. He was always stopping to talk to people. Lots of times they would tell him their problems and ask if there was anything he could do about it. If he could, he took young Gerard with him. It had been so hard being away from his family when he was in prison. Now, he was able to see them and he was doing work that made him feel like he was helping his community and maybe even building a new way of life. He was pretty happy.

Friday 6th March 1981

There was no priest in last night or tonight. They stopped me from seeing my solicitor tonight, as another part of the isolation process, which, as time goes by, they will ruthlessly implement. I expect they may move me sooner than expected to an empty wing. I will be sorry to leave the boys, but I know the road is a hard one and everything must be conquered.

Bobby was beginning to feel a bit weak now. But he had slept well and even had pleasant dreams. None of his bad headaches either, which was a real blessing to his morale.

That evening he stared at his dinner, which the guards had left on the table for hours. They were heaping enormous plates of food in his cell now and Bobby figured they were counting every bean and chip, weighing every plate of food.

"The damned fools", he thought to himself, "they don't realise that the doctor tests me for traces of any food eaten. Not that it mattered", he thought, "I have no intention of sampling their tempting morsels."

Bobby heard that day through the grapevine that his friend Jennifer had been sentenced to twenty years in prison for an attack on a policeman. Jennifer had been just sixteen when he last saw

her in Twinbrook. She was one of the keen young activists who Bobby spent hours and hours with back in those days, talking about the freedom struggle and how to motivate people in the community to become involved in radical politics. He saw the young girls and boys as the future of the struggle, the future of Ireland. Back in that summer of 1976, he saw his friends and comrades being arrested all around him. His best friend, Séanna, was arrested in August and that was a big blow to Bobby. Other friends were in jail, and some were even killed by the British army. So Bobby was more certain than ever that there was more to their struggle than the armed activities of the IRA.

"Broaden your base, Republicanise your area, intensify the armed struggle", he told them over and over. If the IRA just tried to carry on a war against the British without thinking about the people in their communities they were weakening themselves. All it would take would be to arrest a few key people and the whole struggle in an area like Twinbrook would collapse. But if they politicised the whole community and got them involved in running their own lives then the British could never defeat them. There would always be someone else to step in whenever someone was arrested or shot.

Bobby started organising the young people around activities like writing and distributing their paper, Liberty. He got them involved in activities in the Tenants' Association's social club. Young teenagers like Jennifer looked up to him. She felt that Bobby treated each one of them as if they were special. He always listened to what they had to say. He went out and sold newspapers with them. He went door to door with them collecting for the prisoners. He stepped up their political education and he made a special point to encourage women to become more active. He organised a series of lectures for them about respecting the community and gaining respect from the community.

"The Republican Movement is nothing without its people," he told them. "Our main objective is to keep that support and build on it."

Now Jennifer had reaped the worst result of following Bobby's advice. He felt both proud and responsible. He wrote in his diary that he was 'greatly distressed'.

Despite his distress, Bobby decided that he had no regrets about his actions. Even if his son, Gerard, or his nephew, Kevin, became involved, he knew it would be the right thing for them to do. That night he wrote in his diary,

"They will not criminalise us, rob us of our true

identity, steal our individualism, depoliticise us, churn us out as systemised, institutionalised, decent law-abiding robots. Never will they label our liberation struggle as criminal."

But Bobby had been in a fight against time as that summer of 1976 came to a close. Not content to arrest IRA members the army and the police were now coming into Twinbrook, wrecking homes by punching holes in the walls and ripping up floorboards. They arrested young activists on the streets, confiscating their newspapers and taking them in to interrogate them about their political activities. Bobby was defiant. He wrote a press statement saying, "We are here to stay and if the Brits don't like it then it's just hard luck."

But the young people around him were starting to worry about Bobby. They knew that he was continuing his armed activities as an IRA volunteer and some of them tried to tell him that maybe he should just stick to political work. He was too valuable to them to lose if he was arrested. But Bobby believed it was important to continue the war militarily against the British and he could never ask anyone else to do something he was unwilling to do. So he kept up his IRA work, even though he knew that it would eventually land him back in prison.

And now, here he was. He had been back in

prison for more than four years, and in conditions that were worse than he ever could have dreamed back then in Twinbrook. Bobby's thoughts came back to his cell. He thought about other Irish heroes who had been on hunger strike before him: Thomas Clarke, Terence MacSwiney, Frank Stagg and Michael Gaughan. He knew he was likely to follow them to the grave.

"Dear God, we have so many that another one to those knaves means nothing."

He lay in his cell that night weakened by the hunger. His body was now beginning to eat away at itself since he was feeding it nothing. It was a lonely and hard road that he was taking. As usual, when he thought about such things he took comfort in the birds. They were the only things left in that prison that were nearly normal. He heard a curlew passing over his cellblock.

"Such a lonely cell, such a lonely struggle", he told himself. "But this road is well trod and he, whoever he was, who first passed this way, deserves the salute of the nation. I am but a mere follower."

Saturday 7th March 1981

I am now convinced that the authorities intend to implement strict isolation soon, as I am having trouble in seeing my solicitor. I hope I'm wrong about the isolation, but we'll see.

It's only that I'd like to remain with the boys for as long as possible for many reasons. If I'm isolated, I will simply conquer it.

On Saturday, Bobby awoke and he started to worry about isolation. It had not been too bad, so far. He got to talk to Philip Rooney in the next cell, and he could shout across to the other lads on the landing, across from his cell. He had things to read, which were like gold dust after three years without any. And he even had his smokes. Decadence? Well, maybe, he thought, but who's perfect.

"Bad for your health", he thought, turning the prisoners' black humour back onto himself.

Bobby was convinced that the authorities would try to isolate him soon, probably by sending him to the prison hospital. They had started keeping him from seeing his solicitor and he thought that this was a bad sign.

When the medic checked him, Bobby weighed 61 kilograms. He had lost three kilos during his first week of fasting. At least, despite the heaps of

higher quality food the guards were leaving in his cell, he never got hunger pangs or really cared to eat. Funny, but food seemed to be one of the least of his worries even though the lack of it was slowly eating him up and would eventually kill him.

Bobby read his paper. It had an article about his friend Jennifer and what she had said in court. When the judge sentenced Jennifer to twenty years imprisonment in Armagh women's prison she stood up and told him that she was a political prisoner and that she would stand by her comrade Bobby Sands who was on hunger strike to defend her rights as a prisoner. Bobby thought back to the last time he'd seen her in Twinbrook. She was one of the young ones who worried about his military activities in the IRA. What would happen to the struggle if Bobby got caught, like so many others were being caught? Had they been right?

It was a grey and rainy October day, a typical stinkin' Belfast day, when Bobby and his comrades were caught at the Balmoral furniture showrooms. He was sitting in the back of the car with Joe McDonnell and Sean Lavery. Seamy Finnucane was at the wheel. They watched the people running from the warehouse to get out before the bombs went off. It was part of what the IRA called their 'economic war'. Bombs like this

were not meant to hurt anyone, just to cause so much damage that the British government would decide that it was too expensive to keep fighting their war against the IRA. It was dirty business, but maybe things like this would convince the British to leave Ireland. That was a thing about capitalists, thought Bobby, they didn't seem to care much if a lot of poor Irish or even English people got killed, but they cared about their

money. Maybe they would think again about staying in Ireland if their pocketbooks started hurting enough.

Bobby and his three comrades could have got away. But they were not alone. There were other comrades trying to escape from the furniture warehouse. They tried to get to their van to make their getaway but the street was blocked up with cars. It was a mess. Bobby and the others decided to wait, just in case the others tried to make it to their car and they could all then get away. But then an unmarked British army car came round the corner and blocked them. Seamy tried to get out of the front door to make a run for it but the police were too quick and blocked his way. The four men sat back in their seats.

"That's it, they've got us now", they told each other. "Don't say anything. Just hold it together and we'll get out of this thing", one of them said, to encourage the others. But they all knew that there was no way out. Then there were shots. The four men sat stunned as they watched a British soldier get down on one knee and fire his pistol at Seamus Martin, one of their comrades, who was unarmed. He hit Martin in the stomach. Policemen joined in and they continued firing at the others who were escaping, even as they ran through the crowd of people who were running out of the

furniture showroom. They hit one man, Gabriel Corbett, in the back.

It was a strange thing. They were caught outside a furniture warehouse that was full of firebombs yet they were amazed at the recklessness of the soldiers and policemen who fired into the escaping crowd. Firing into a crowd was something they would never have done. But, of course, leaving bombs in a warehouse was something the soldiers would never have done, either.

Finally, after the commotion was all over, the police handcuffed Bobby and his three companions and put them into the back of a police landrover. They were on their way to interrogation — a frightening prospect. Everyone heard horror stories about police interrogations in the centre they called, 'Castlereagh'.

A screw came round to the cell and shook Bobby out of his daydream...or was it a nightmare? So many things happened in a war. There was such a distance between the two sides. Could they ever be reconciled? Maybe that was why the screw looked at Bobby the way he did. Ever since he started his hunger strike they all stared at him, perplexed. Bobby thought most of them probably hoped that he would die. They simply could not understand how a man would willingly go on hunger strike knowing he was

likely to die. But, for all that, Bobby thought the ordinary guards were not so bad as the men who ran the prison. He wrote about them all in his diary that night.

"There is only one thing lower than a Screw and that is a Governor. And in my experience the higher one goes up that disgusting ladder they call rank, or position, the lower one gets."

Bobby lay in his bed and listened to the rain until he finally fell asleep.

Sunday 8th March 1981

In a few hours time I shall be twenty-seven grand years of age. Paradoxically it will be a happy enough birthday; perhaps that's because I am free in spirit. I can offer no other reason.

At mass Bobby finally saw the other blanketmen. It was the first time in years he'd seen them washed and clean, without beards and with their hair cut short. Some of these men he had only ever seen with dirty, matted, long hair, and grubby beards to match. Now it was difficult to recognise them.

Some of the men were a bit awkward with Bobby, not quite knowing how to treat him or what to say to him. They kept their conversations short. A priest from the US said mass, and he asked everyone to pray for the young man who was on hunger strike, not realising that Bobby was present. Philip Rooney looked over at Bobby as the priest was speaking and he began to feel a bit sad. Bobby looked lonely to him. The priest talked some more about how he had spent time in prison in the US because of his opposition to the US war in Vietnam.

Back in the cell Bobby read some wildlife articles in the papers and he thought again about

how he had once thought of becoming an ornithologist. He thought about the lark, the bird that symbolised freedom to him. Once he had written a story about 'The lark and the freedom fighter'.

The birds had always been his companions even when he was in solitary confinement. The one thing he could always count on was to look out and watch the birds. It was like a television show unfolding from his cell window. Sometimes it even got him through the worst of times. One summer, maggots started crawling all over their filthy cells. Everybody was disgusted. The maggots got caught in their matted hair and they had to burst them to get them out. When he walked across the cell floor Bobby felt and heard the crunch of their bodies under his bare feet.

But the birds helped him through. Bobby took handfuls of maggots and threw them out the window to the birds who gorged themselves on the tasty meal. Bobby spent hours watching them fight over the maggots. He hated the big bullies who stole food from the little birds. And he cheered when several of the small birds got together to run off the bullies and win back their food. Bobby thought the birds were a lot like people. The big and powerful tried to steal from the weak and the only way the weak could defend

themselves was to band together and to look after each other. Sure, wasn't that what the blanketmen were doing in the prison? If they stuck together, they could defend themselves against all the things that the prison administration was trying to do to them.

But there had been times when Bobby did not have the birds for comfort. There was the week in Castlereagh interrogation centre just after he was arrested with the others in the car. Then, after his trial, he spent nearly a month in punishment in the Crumlin Road Jail. The cell was cold and dark and the window, high up the back wall, gave him no view of birds, or anything else for that matter. That may have been the worst time he ever spent in prison.

Castlereagh. That was a name that sent fright through a lot of young men. The stories of beatings and different forms of torture that the detectives dished out there made some men sign statements admitting their guilt even before they were questioned. But Bobby and his three comrades never admitted anything. They went through days of endless interrogation sessions where two detectives would question them for hours and then leave, only to be replaced by two fresh detectives. And it wasn't much better back in the cell, where there were no windows and the white light shone

all the time. You never knew if it was day or night. It was all meant to disorientate you.

Years later, Bobby wrote about it in a poem that he called The Crime of Castlereagh.

'Twas ten to nine, for that's the time
I heard the Watcher say.
But was it light or was it night
I ne'er knew either way.

In Bobby's cell was a hard prison bed with sheets and blankets, a chair, white walls and that was it. No reading materials or exercise. No access to solicitors or visitors. No view outside. The food was too cold. The room was too hot. The air vent rattled overhead. White noise.

The bright white light gave no respite
And cut the eyes to shreds,
And left an ache to devastate
Already bursting heads.

But the worst part was the waiting. Bobby waited and waited in his cell for the guard to call him to go down to interrogation. That was the part prisoners dreaded. Bobby said that the detectives started beating him right away.

"I was spread-eagled against the wall with my finger-tips only high up against the wall and my

feet spread apart and back as far as I could manage. The detective who was reeking with alcohol was punching me in the kidneys, sides, back, neck, in fact everywhere. The other detective was holding me by the hair and firing questions into my face...I was told to sit down, given a cigarette and soft soaped with promises, deals, etc...

"While the detective was sitting in front of me he was swinging his foot and kicking me in the privates. I fell twice only to be hauled to my feet in the same position. That same person was chopping me on the back or neck, the individual blows heavy and continuous, about twenty or thirty times. I am not sure as the other detective was punching me in the stomach and yelling questions...I was given another cigarette and asked if I was all right and told it was early days yet, so I could make it shorter and easier for myself if I just put my name to a piece of paper...I had been beaten and interrogated for about seven hours..."

This kind of treatment went on for days. Bobby just told the detectives that he was at the furniture warehouse looking for a job. When people shouted 'bomb', he ran out and jumped into a car with three other fellows. He knew the detectives would never believe him but it was his story and

he stuck with it. The others told similar stories. Except Sean Lavery, who just sat there and looked at the detectives for hours on end.

Bobby spent four days in Castlereagh. The detectives put him through thirteen interrogation sessions, lasting from twenty minutes to two hours. In total, he was under interrogation for 17 hours and 35 minutes. He says he was beaten through the whole time.

Yet it was not all one way. Bobby had his own ways of dealing with interrogation. He played little games to get back at the detectives. He waited until they weren't looking and he stole cigarettes and matches from them, hiding them up a seam that he'd ripped out of the leg in his trousers. Things like this gave him small victories and raised his spirits.

> *I'd torn my jeans twice at the seams*
> *And hidden matches there.*
> *For men must use each little ruse*
> *And take each passing dare.*
> *If one had luck a lousy butt*
> *Could calm the nerves no end.*
> *For cultures taste takes second place*
> *When you're in hell, my friend.*

He played other games with the detectives. When they tried to make him talk, he was silent. When they asked a question, he sang a song. He

smiled at them when he thought it would irritate them most. And he was always asking to go to the doctor or the toilet, anything to break their pattern of questioning. Then, back in the cell, he sang more songs. He may not have had birds, but they could never take away his songs.

Finally the detectives gave up. They took Bobby and the others back to the police station in Dunmurry, charged them, and then sent them to the Crumlin Road Jail to wait for trial. The jail was no great place but there at least they had other prisoners for company, windows and views, and birds.

Waiting for trial in Crumlin Road Jail was a sad time for Bobby. He was only there a few weeks when he found out that Geraldine had a baby but it was born premature. The baby was tiny and weak and it never had a chance. It died within days. Bobby experienced a lot of emotions. He felt guilty that he had let his family down and now he was in jail and unable to be with them at their darkest hour. He missed them terribly. So he did what a lot of adults do when they are under terrible pressure: he got to work and tried to avoid all of the bad feelings he had by keeping himself busy.

Things were different in jail now from the time he was in before. Back in the 'cages', the prisoners had run the place themselves. Oh, they

had arguments with the guards, but mostly they were able just to run their own lives. Now, however, the government was trying to impose a new lifestyle on the prisoners. It was a policy called criminalisation. Under this new policy, when the guards gave orders they expected the prisoners to jump. They wanted them to say, "Yes sir, no sir…". Always 'sir'. And the prisoners didn't have names; only numbers.

"Get in your cell and be quiet, 1066", the guard would say. And he expected "yes sir!" in return. They were treating republican prisoners like all the other prisoners — like criminals. Yet Bobby and his comrades knew that they were political prisoners and not criminals so they refused to follow orders or to say 'sir'. Most of all, they refused to wear the uniforms that marked them out as criminals. But this conflict with the guards meant a lot of work. The prisoners had to stay disciplined. Everything had to be kept under control. So Bobby kept himself busy and he tried to forget that he never had a chance to grieve for his young child or to be with his wife and his son.

After nearly a year of this, Bobby's trial finally arrived. He was taken with his three co-defendants through the tunnel that ran under the Crumlin Road across to the courthouse on the other side of the road. There they were led up the stairs into a

fancy courtroom with chandeliers and high walls. The judge and the legal teams and all of the solicitors and barristers sat at the front. The families of the accused sat at the back, behind a screen, and watched their loved ones as they were tried and condemned.

There was never much doubt about Bobby and his comrades being covicted. They were charged with bombing the furniture warehouse and with possession of a gun that the police found in the car after they blocked their escape. Sean Lavery said that it was all just a 'kangaroo court' and he just sat and read a novel while the trial went on. Joe McDonnell sat and made jokes. He would not even lower himself to recognise this court because he felt there was no justice in a court without a jury, headed by a judge who had already decided they were guilty. But Bobby and Seamus watched the proceedings carefully. They wanted to see if anyone made any mistakes. Maybe they would shout out the truth if someone told a lie. Or they might hear something that they could use some day to appeal the guilty sentence that they all knew they would get.

In the end they were surprised. The judge found them all innocent of the bombing charges. But their pleasant surprise was cut short when he said that they were guilty of possession of the gun and

sentenced them each to fourteen years. Fourteen years for possessing one-quarter of a gun! It seemed like a heavy sentence. As the condemned men turned to leave the court, Bobby's mother shouted out to him,

'Take care, son.'

As Bobby raised his hand to wave back at his mother one of the guards hit him hard. All hell broke loose. Joe McDonnell jumped the guard in Bobby's defence and then Seamus jumped in the fray as well. It was a short fight but it was enough to ensure that they would be badly punished. The court could hardly allow condemned men to attack their guards even if it was in self-defence. And that is how Bobby spent time in a bleak dark cell, without even the pleasure of birds to keep him company.

The next day, Bobby and Joe McDonnell and Seamus Finucane were put in solitary confinement in the punishment area of the Crumlin Road Jail. Bobby called these cold old Victorian cells, 'filthy ancient concrete tombs'. They were like the other thick-walled cells in the jail except that the tiny windows on the back walls were too high to see out, and the cells were shadowed by another wing. They were dark and they were cold. The prisoners bunched up religious pamphlets in their socks and used balls of paper to play handball against the

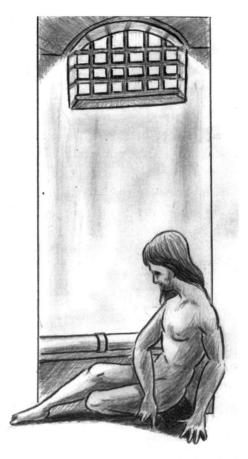

cell walls to keep warm. And Bobby tried to pass the time by singing songs.

On the sixth day, the prison governor saw them and he told them to wear a prison uniform, like an ordinary criminal.

"We are political prisoners, we'll not be wearing your uniform", they told the governor. So he put

them on a starvation diet, three days on and three days off, for the next fifteen days. And they were naked, with only their blankets to wear since they refused to wear the uniforms. Years later, Bobby wrote about his time in the punishment cells.

Having appeared before the Governor and received your sentences, your punishment really begins. The next morning you are woken at 7.00 a.m. by a bang on the cell door. It is now December and the mornings are dark and very cold. You must rise naked and shivering and fold up your bedding and mattress (no bed for the next three nights, just the hard mattress on the floor). The Screw opens the door at 7.30 a.m. and you leave your bedding out in the corridor. Again head for the toilet, naked as usual, to empty the Chamber-pot. When you return and the Guards slam the door shut you are left there standing naked and freezing, with the wind howling in through the holes in the windows. There is only one thing for it and that is to do exercises to keep warm, but your feet stay blue with cold, no matter what you do.

...To pass the time you try to read a page or two from the bible, but it's too cold, so you sing a song or two to yourself, periodically continuing your exercising to keep warm, right through to dinner time.

By dinner time you are thoroughly frozen and starving. The dinner arrives at 11.30 a.m. It's two small scoops of potatoes covered with a ladle of soup. You 'wolf' this down you in less than a minute with the plastic spoon they give you. You have to stand with a steel tray in one hand and eat with your other hand. When the steel tray is too hot to hold you must set it on the ground, get down on the floor on your knees, lean over your dinner like an animal and eat it as best you can. You must eat everything, leave nothing or you will really feel it later on.

Having eaten your dinner you still feel hungry as ever and equally as cold and miserable. You know you could simply end it all by putting on the prison garb and calling for a screw but you don't. You know that this torture is geared to make you do just exactly that, to break your resistance. You know that you are a POW no matter what they may try to do to you.

...Your morale is ebbing drastically. When you hear a few thumps on the wall, one of your mates giving you encouragement, you remember that he too is in the very same predicament. So, encouraged by a few thumps on the wall, you snap out of your depression and rally yourself for the final hour or so until you get your

bedding back in at 8.30 p.m.

It seems like hours but you make it. It's the greatest feeling in the world, when the door opens and the guards tell you to take your bedding in. You throw your hard horse-hair mattress into the corner on the floor. As soon as the door shuts you arrange your bedding and sheets into some sort of order and get underneath them. After a few minutes you feel yourself warming up. You're exhausted, and tomorrow will be much worse. You say a quick few prayers in gratitude for surviving that day, and ask for assistance in the coming battle. You drop off to sleep thinking of better days and your family.

But it seems only a few minutes when the door bangs again and it all starts again.

Bobby finished his diary and lay in bed still thinking about nature and birds. Yes, birds had always been his companions. And now, lying on what he called his 'death bed', Bobby wondered would he live long enough to see the lark again.

"Well", he thought, "I can still listen, even to the black crows".

Monday 9th March 1981

It is my birthday and the boys are having a sing-song for me, bless their hearts. I braved it to the door, at their request, to make a bit of a speech, for what it was worth. I wrote to several friends today including Bernie and my mother. I feel all right and my weight is 60 kgs.

Bobby woke up to his twenty-seventh birthday. It was the tenth birthday in a row he had spent in jail. Strangely though, he felt it would be a happy enough birthday, "because I am free in spirit".

He hadn't felt so free on his twenty-fourth birthday. That was his first birthday in the H-Blocks, as a blanketman. Just like a few hundred other men he had been brought to the H-Blocks after his spell of punishment in the Crumlin Road Jail was over. The men that he found in H-Block number 5, or H5 as it was called, were staunch in their protest. In fact he had never seen such political will. These young men were living naked, with just a towel to wear around their waist and a blanket draped over their shoulders, because they refused to be branded as criminals. They refused to wear a criminal uniform or do prison work. They demanded respect and dignity.

That was the good side of things. The bad side of things was that their protest did not seem to be

85

going anywhere. These men could lie here like this forever he thought and the British government wouldn't give a damn. He thought about O'Donovan Rossa. Rossa had said that it was not those who inflict the most but those who can endure the most who would win in the end. Well, these men were certainly enduring. But winning would take more. There had to be some kind of a popular support movement for them, people outside the prison to come into the streets and campaign for them. Otherwise the British would just let them rot there indefinitely.

Bobby's first cellmate was Tony O'Hara from Derry. Tony was typical of a lot of the blanketmen. Bobby watched him for the first few days. Tony would get up for his breakfast and then lie back down on his bed and sleep until lunch. Then he'd nap all afternoon. After supper, he went back to bed. Tony figured there was nothing else to do. They were kept in their cells, 24/7, no radios or TV, no reading materials except the bible and a religious pamphlet or two. What else could they do but sleep?

Bobby watched Tony for a couple of days. While Tony slept, he wrote things on toilet paper with a smuggled pen refill, or scratched writing on the wall with anything sharp, like the tab from a zipper. Then Tony woke up for awhile and they

talked and then Bobby was left on his own again. After a couple of days of this Bobby turned to Tony over dinner.

"What do you do all day, Tony?" he asked.

"I sleep. What else is there to do?" Tony replied.

"Well…isn't that a waste of your opportunities?" scolded Bobby.

Tony could not quite make out what Bobby meant by 'opportunities'. What opportunities did they have in their present condition? But Bobby soon showed him. He wrote articles on toilet paper, describing conditions in the H-Blocks and smuggled them out through his mother on visits. Soon they were appearing in the newspapers. Most of the prisoners, including Tony, refused to go on visits. To do so they would have to wear the prison uniform and they thought that that would be a form of surrender. But not Bobby. He said to Tony that they should all be going on visits. That way they could tell their families and friends about the horrible things that were happening in the H-Blocks. They could write articles and letters and smuggle them out. It was the only way, he said, to build a mass support campaign. Otherwise, they might just lie there for years in their blankets wasting away.

Bobby showed other ways to find 'opportunities'. He began teaching Irish by

shouting lessons out the door. It was hard at first, but they had lots of time. Only he and his friend, Séanna, and a couple of others had Irish. But soon lots of blanketmen were speaking Irish out their cell doors. It raised their spirits. They could speak to each other without the guards knowing what they were saying. They felt like they were 'getting one over' on the guards. At night they had singsongs and bingo and other entertainments. They were winning small victories.

But these things were only starting when Bobby celebrated his twenty-fourth birthday in H5. There was still a long way to go, and no one could be sure that they would ever get there.

But then something happened to change everything. Bobby's old friend Brendan Hughes (they called him 'the Dark') got caught up in a fight in the cages, the part of the prison where Bobby had been before, and where the prisoners still had political status. The prison officials charged the Dark with assaulting an officer. Since this was a new charge, which they considered to be a 'criminal' charge, the prison authorities moved the Dark into the H-Blocks. In the morning he was an officer of the IRA and the prison guards called him 'Brendan' — that afternoon he was naked in a cell and the guards called him by a number and ordered him to call them 'sir'.

The Dark talked to Bobby a lot about the state of the blanket protest. He agreed with Bobby about a lot of things, like the need to step up the protest both inside and outside of the jail. He figured things were getting stagnant.

So when the men made him their commanding officer the Dark told them to start going on visits. He said they had to start smuggling messages and tell their people about what was going on. Not only that, they could smuggle tobacco back in. For the prisoners on protest tobacco was a luxury, the only real luxury they had. They didn't all smoke but even the men who didn't smoke had their spirits lifted when there was tobacco on the wing. It was a funny thing. Sometimes you would start out doing something for one reason, and you would find that it had other benefits besides what you had first expected.

When the men started going on visits it caused something else they had not expected. It wasn't long before the guards realised they were smuggling things back and forth so they began searching the men more and more carefully every time they went to a visit and from visits. Visits became a confrontation. Prisoners started getting beaten up. The guards outnumbered them and would search the prisoners by force, looking for a smuggled bit of paper, or tobacco, or pen refills.

But this also had a good side. It lifted the prisoners out of their stagnation. The daily confrontations made them feel like they were actively fighting again against injustice.

Bobby was woken out of his reverie by a visitor to his cell. As a sort of birthday gift the Governor

allowed Philip Rooney to come in and brush his cell. Bobby had been in solitary confinement now for a week so it was great to talk to someone again face to face. He also received a lot of birthday cards and that night the other prisoners gave him a birthday concert.

Concerts and other forms of entertainment were important to the men. They had been living in such awful conditions for the past three years without even the simplest forms of entertainment, like a book to read, so they had to do other things to keep up their morale. They had regular concerts and, of course, Irish classes and history lectures. They even had a couple of talent contests where Bobby was the Master of Ceremonies. But the best form of entertainment was the 'book at bedtime', where one of the men told a book or a movie from memory usually for several nights running. Most of the men agreed that Bobby was the best storyteller in the H-Blocks. He told novels like Trinity (about the Irish struggle for freedom) and How Green Was My Valley (about the Welsh miners and the conditions in which they lived). He told of the life of Geronimo, the Apache warrior. But the book most of the blanketmen remembered was about a young man called Jet who deserted the US Marines because of the inhumanity they caused in Vietnam. Like the blanketmen, Jet

suffered a lot for his principles. He was always on the run, chased by the US government and their hired thugs. But Jet was also free. Bobby described him and his girlfriend riding across the American plains on his Harley motorbike, their hair blowing in the wind and rock and roll music blaring out of the radio. For a few hours the prisoners also felt free as they heard about Jet and his exploits. It raised their morale and made Bobby Sands their leader.

Now, though, after nine days on hunger strike, Bobby was too tired to sing or tell a story. But before the concert began the men asked him to say a few words. He got up to his door and told the lads that it had been a pleasure to go through this time with them and how he was glad of their support. He spoke to the young prisoners about the bravery they had already shown and told them to dedicate their lives to the struggle. He talked about why he was on hunger strike, that it was not just about clothes or about the five demands but about their right to resist injustice. He said that he expected to die but that he was willing to do it for an Irish socialist republic. Then everyone sang a song or told a joke or a poem out the cell door. Bobby's old friend Tomboy sang Bobby's song, 'The Voyage'. Tom McElwee lifted the lids off the two piss pots in his cell, placed them on the floor,

and did a tap dance to wild applause.

After the concert Bobby wrote to his comrade, Liam Óg, and asked him to send in a book of poems by his favourite poet, Ethna Carberry. He had not lost his sense of humour and he made fun of himself. "Last request", he wrote to Liam Óg. "Some ask for cigarettes, others for blindfolds, yer man asks for poetry." Then he wrote his daily diary insertion. It was late and he was cold. He thought about some of his heroes, other men who died for Ireland, like James Connolly and Liam Mellowes. He finished his insertion with a defiant, although resigned note about the future.

"Well, I have gotten by twenty-seven year, so that is something. I may die, but the Republic of 1916 will never die. Onward to the Republic and liberation of our people."

Tuesday 10th March 1981

Tomorrow is the eleventh day and there is a long way to go. Someone should write a poem of the tribulations of a hunger-striker. I would like to, but how could I finish it.

Bobby's birthday lasted into the next day. The guards gave him a copy of the Irish News and there were birthday greetings in it from relatives and friends. He also received a bag of toiletries, which, under the circumstances the prisoners had been living in, was quite a luxury.

Bobby was starting to worry about the hunger strike. In particular, he worried that the priests and the politicians would try to get it ended without the blanketmen achieving their aims. The blanketmen were fighting to be recognised as political prisoners but even priests with the best intentions misunderstood their struggle. The priests thought that the blanketmen were just fighting against the inhuman conditions in the prison. But Bobby made it clear in his diary that they were after something much deeper and more profound. He wrote about it at some length.

"It is the declared wish of these people to see humane and better conditions in these Blocks. But the issue at stake is not 'humanitarian', nor about better or improved living conditions. It is purely

political and only a political solution will solve it. This in no way makes us prisoners elite nor do we (nor have we at any time) purport to be elite.

"We wish to be treated not as 'ordinary' prisoners for we are not criminals. We admit no crime unless, that is, the love of one's people and country is a crime."

Not that Bobby had anything against the ordinary prisoners. He hoped that they too would make some gains out of their struggle. All prisoners should have better conditions, he thought.

Bobby started wondering when the authorities would move him and try to isolate him. He looked at the cell around him. It was far from clean, but tolerable. He'd been six days without a bath. But, no matter, the water was always cold and he was afraid that if he took baths he might come down with a cold or the flu. That would be a disaster because then he would have to come off of his hunger strike.

It was strange to be thinking about these things. Just a couple of weeks ago Bobby's life had been so different. Then, they were still on the 'no-wash' protest, living in filthy cells.

It had all begun back in that spring of 1978, after the Dark was moved into the H-Blocks. It was a funny thing, but ever since the Dark joined them as a blanketman the authorities had always kept Bobby in the cell next to him. They had become as

close as two men had ever been. Everything the Dark did, every decision he made about their protest, he discussed with Bobby first. Sometimes they talked for hours, often with their head against the heating pipes at the back of their cells so that they could talk to and hear each other through the cracks around the pipes.

It was back in March that year that things changed dramatically. Bobby was sharing a cell in H5 with Ginty Lennon, the brother of his old friend Danny Lennon. Bobby and the Dark were trying to find new ways to intensify the protest, to put pressure on the authorities. Once they started taking visits and smuggling writing materials and tobacco it did not take long to find a way to step up the protest.

The way the guards reacted to the smuggling was to invent new ways of searching the prisoners. They were often violent and always meant to be degrading. First, the guards strip-searched the men, often probing up their backsides with their fingers to try and find anything that they had hidden inside their bodies. Later, they made them bend over a table so that they could search deeper inside. And then they tried to make them squat over a mirror.

In these conditions, it was hardly surprising that going to and from visits became a running battle between the prisoners and the guards. Pretty soon there were battles whenever the prisoners left their

cells for any reason. The guards reduced the number of times the men could leave their cells to wash or to 'slop out' (empty their piss pots). They even starting hitting some of the young prisoners when they left their cells for the washroom.

"If the young fellows can't wash, then none of us will wash", said the Dark.

On the Monday after St. Patrick's Day the blanketmen told the guards that they would no longer wash, nor would they clean out their cells. A new phase of struggle that the blanketmen called the 'no-wash' protest, and the newspapers called the 'dirty protest', had begun. The guards responded by picking out a dozen men at random and putting them in the punishment cells without beds and on a diet of bread and water. The following Monday the prisoners refused to leave their cells to slop out or to fill their water containers. It was not long before the guards started kicking the pisspots over the prisoners' beds. When the prisoners tried to empty their urine under their cell doors the guards came along and squeegeed it back into their cells. When the prisoners built dikes out of bread to keep the urine out of their cells, the guards broke the dikes with coathangers and sent it back in again.

Every Monday the blanketmen found a new form of protest. They threw their dirty sheets out

of the cells when the guards refused to give them clean ones. They threw their extra food into the corners of their cells. Eventually, they broke up their furniture and threw it out the cell windows.

You would think that all of these things would add to the prisoners' miseries. They had little enough and now they had no sheets or furniture. Their filthy foam mattresses were swimming in urine every morning and nasty piles of food were moulding away in the cell corners. But it's a funny thing. Sometimes even when you give up something that makes you comfortable you gain something much more important — pride in taking control over your own environment. This is how Bobby and the rest of the prisoners felt. They were losing what little material possessions they had but their spirits were sky high because they felt like they were in control. And when they saw the dread on the guards' faces each Monday, wondering what kind of protest would come next, they really felt like they were winning.

But the situation kept worsening. Soon, whenever the prisoners tried to throw their shit out of their cells, the guards just threw it back in. It was the one thing they could not get rid of. So they had only one choice: they spread it on the walls of their cells.

Can you imagine what it would be like to live

in a filthy prison cell with you and your cellmate's shit spread all over the walls? Well, that was how they lived for the next three years. Nobody wanted it that way, but the blanketmen

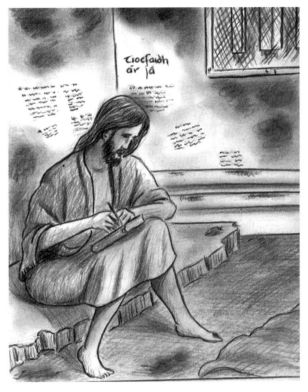

all felt that it was the only way they could keep their dignity.

And now, here he was, still fighting for his dignity. But this time, Bobby knew that the price would be his own life.

Wednesday 11th March 1981

I am the same weight today and have no complaints medically. Now and again I am struck by the natural desire to eat but the desire to see an end to my comrades' plight and the liberation of my people is overwhelmingly greater.

Bobby's birthday seemed to be lingering. It was two days ago already but he awoke to loads of birthday cards and a bouquet of flowers from an old Belfast woman who always did what she could to support the prisoners. There was a card from a newspaper reporter and even one from a student in America who he didn't even know. He also had some smuggled letters from friends and comrades.

Bobby still felt hungry sometimes but he knew that it was important to fight the urge to eat. Besides, he had been hungry before. Back in 1979 the prison authorities moved all the 'leaders' of the blanketmen together into one H-Block, H6. That was quite a year. After all the fights and conflicts they had experienced during 1977, and now with the cells filthy and the jail a total mess, the authorities must have figured they could split the leaders from the rest of the blanketmen and break the protest. But that didn't happen. The lads in H6 used their time together to plan and step up the protest and sometimes just to have a great time

together. It was a thing that some people call solidarity. In those extreme conditions they achieved a level of solidarity and sharing that none had experienced before. They spent the year learning Irish, telling stories and singing songs, and planning new protests. All the guards could think of to punish them was to starve them. One blanketman counted his cornflakes in the morning as they swam around in the gray watered-down milk. There were thirty-five. But their solidarity fought off the starvation.

Bobby used his time productively in H6. He organised the men into a letter-writing factory. He would write sample letters to famous and important people and tell the others to beef them up by adding in details of their own lives and their experiences in jail. The men wrote thousands of letters to movie stars, rock musicians, trade union leaders and politicians.

To get all the materials they needed, Bobby worked with a group of women on the outside who smuggled pens and cigarette papers and stretch-and-seal into the jail and smuggled the letters back out. Some of the young women visited two or three prisoners a day to make sure all the messages went in and out. To the blanketmen, these young women were true heroes. They even smuggled in some miniature radios so that the

blanketmen could keep up with the latest news.

Bobby wrote more and more articles, stories, and poems. He read them to the other men at night. In the conditions they lived in — small cell, no clothes, no books, no exercise, nothing — the only freedom they had was in their minds. In their imaginations they could escape the prison and be free and Bobby's stories and songs always helped.

Bobby had written about it all in a story he called, 'The Window of My Mind'. It was the first story he wrote under the pseudonym 'Marcella', a name that he would use constantly thereafter, by which the world would come to know him and his writings. He wrote,

"When one spends each day naked and crouching in the corner of a cell resembling a pigsty, staring at such eyesores as piles of putrefying rubbish, infested with maggots and flies, a disease ridden chamber pot or a blank disgusting wall, it is to the rescue of one's sanity to be able to rise and gaze out of a window at the world."

But out that window was "a view of nothingness, unless a barbed wire jungle and rows of faceless tin timbers offer an artificial appreciation unknown to me". Still, as grey and monotonous as the landscape was, there were some pleasures. Bobby could watch the birds at play, a thing that always gave him joy and reminded him of his

childhood.

But there was a problem that moved Bobby to write about the window of his mind. The workmen had come around to block out the windows with steel sheets so that the blanketmen would not even have the few pleasures of the birds or the clouds to distract them from their conditions. Bobby thought about what they were trying to do to him and his comrades. He wrote,

"A few words I once read came echoing back to me today — 'No one can take away from a person his or her ability to contemplate. Throw them into prison, give them hard labour, unimaginative work to do, but you can never take from them the ability to find the poetry and music in life' — and I realised that they, here, my torturers, have long ago started and still endeavour to block up the window of my mind."

That may have been a turning point, the straw that broke the camel's back, as they say. Bobby and his comrades had endured many tortures and hardships but they could always look out at the sky and think of freedom. Now even that was being taken away from them. Maybe that was the moment when he and his comrades were inevitably pointed toward this hunger strike, the protest that was eating away at his very body.

Thursday 12th March 1981

Physically I have felt very tired today, between dinner time and later afternoon. I know I'm getting physically weaker. It is only to be expected. But I'm okay. I'm still getting the papers all right, but there's nothing heartening in them. But again I expect that also and therefore I must depend entirely upon my own heart and resolve, which I will do.

The hunger strike was beginning to take its toll on Bobby. His weight was down to 58.75 kilos, more than five kilos less than when he started. He was beginning to feel very tired. But it was typical of Bobby to think about the problems of others. He wrote in his diary that, "with each passing day I understand increasingly more, and in the most sad way, that awful fate and torture endured to the very bitter end by Frank Stagg and Michael Gaughan", two Irishmen who died a few years before on hunger strike in English prisons.

"Perhaps, indeed yes, I am more fortunate because those poor comrades were without comrades or a friendly face. They had not even the final consolation of dying in their own land. Irishmen alone and at the unmerciful ugly hands of a vindictive heartless enemy. Dear God, but I am so lucky in comparison."

It was typical of Bobby to think this way. Maybe it was part of the reason why he was willing to make the ultimate sacrifice for his friends. A priest had come to visit him a few days ago and he had asked Bobby to quit his hunger strike. He said it was a sin to commit suicide. But Bobby just quoted Jesus back at the priest, from John 15:13.

"Greater love hath no man than this, that a man lay down his life for his friends."

The priest could say nothing in return.

How had things gotten this bad, so bad that Bobby felt he had to die for his fellow prisoners? And not just Bobby, dozens of other blanketmen volunteered to go on hunger strike, every one of them knowing that he could easily die before they won the right to be treated as political prisoners.

Things had really gone downhill after all the leaders in the jail were moved out of H6 and scattered throughout the other H-Blocks. The authorities must have figured their plan to isolate them had failed so now they were going to move them back with the other blanketmen. They moved Bobby and a few others to H3. Everybody reckoned that H3 was the worst place in the prison. Most of the prisoners there were very young and were very scared. The reason they were scared was because the Block was run by a very violent prison warder who inflicted all sorts of tortures on the

prisoners. They were beaten, searched in rough and undignified ways and forcibly washed with hard brushes that tore at their skin. Their treatment was so bad that most of the men had very low morale. They never went on visits for fear of being beaten by the prison guards. They hardly ever sang songs or told stories at night.

Bobby and the others who came into H3 with him were shocked. Their only real worry in H6 had been the lack of food. But these men were really suffering. The first thing Bobby did was to try and raise morale by organising activities. During the day they started having Irish lessons and history classes, all done by shouting out the door to each other. At night they started having singsongs and storytelling. The first week Bobby organised a singsong where he sang a Bee Gees song and his new cellmate, Dixie Elliott, sang Elvis Presley's 'Jailhouse Rock'. Soon, the prison wing was a hive of energy, just like it had been back in H6.

But now Bobby was nearly two weeks into his hunger strike. He no longer had all that energy he'd had back then. He lay back in his bed and he wrote in his diary. It was getting harder and harder to write. Even such a small activity exhausted him.

"Nothing else seems to matter except that lingering constant reminding thought, 'Never give

up.' No matter how bad, how black, how painful, how heart-breaking, 'Never give up', 'Never despair', 'Never lose hope'. Let them bastards laugh at you all they want, let them grin and jibe, allow them to persist in their humiliation, brutality, deprivations, vindictiveness, petty harassments, let them laugh now, because all of that is no longer important or worth a response.

"I am making my last response to the whole vicious inhuman atrocity they call H-Block. But, unlike their laughs and jibes, our laughter will be the joy of victory and the joy of the people, our revenge will be the liberation of all and the final defeat of the oppressors of our aged nation."

Friday 13th March 1981

I'm not superstitious, and it was an uneventful day today. I feel all right, and my weight is 58.5 kgs. I was not so tired today, but my back gets sore now and again sitting in the bed.

It was Friday the thirteenth and the birds were singing all day. One of the other prisoners threw bread out the window to them.

"At least somebody was eating!" thought Bobby.

The thought of birds singing took him back to earlier days in H3. It was there that Bobby wrote many songs and poems. He had several cellmates and it seemed each one of them had an interesting story to tell him. Bobby turned their stories into songs and poems.

Dixie Elliott was from Derry. He told Bobby all about the people of Derry and their history. While Bobby wrote down the stories and turned them into songs, Dixie drew on the walls. In one cell, he drew a whole mural of Indians fighting General Custer at the Little Big Horn. One day, Dixie saw Bobby writing a poem. When he asked him what it was, Bobby told him that it was a poem about a lonesome boatman and that he got the idea for the poem from a stain on the wall.

Bobby took some of Dixie's tales and wrote a

song he called 'The Voyage', about how Irish men and women had been sent into exile in Australia.

It was 1803 when we sailed out to sea
And away from the sweet town of Derry
For Australia bound and if we didn't drown
The mark of the fetters we'd carry.

Bobby would never know that this song would become one of the most popular Irish folk songs within a decade.

Another song, which would become equally as popular, came to him from the stories of his last cellmate, Malachy Carey. Malachy was from the Glens of Antrim and he told Bobby about a man from his home area called McIlhattan. This man was legendary in the area because he made the finest poteen, or moonshine, that was to be had.

In Glenravels Glen there lives a man
Whom some would call a God,
For he could cure the dead and kill the live
For the price of thirty bob.
Come winter, summer, frost all o'er
Or a jiggin spring on the breeze.
In the dead of night a man slips by —
McIlhattan, if you'll please.

They'd all had some fine times singing these songs. But now the songs of the birds just made Bobby lonely and sad. He got lonely listening to the crows caw as they returned home in the evening. If he heard the lark, his favourite bird, he thought it would break his heart.

"I like the birds", wrote Bobby in his diary.

But he had to stop writing. If he wrote any more about the birds he thought he would cry as his thoughts turned back to the days of his youth. They were good days, gone now forever.

Saturday 14th March 1981

*A*gain, another uneventful somewhat boring day. My weight is 58.25 kgs, and no medical complaints. I read the papers, which are full of trash.

That is how Bobby was beginning to think of his last days. It's hard to imagine that he was going through such a huge event as a hunger strike. He was slowly dying, yet he could describe what he was doing as 'boring'. He was now on his own, without a cellmate to talk to, with no one to look in the face while having a conversation. All of the commitment and energy that he needed to stay on his protest had to come from within himself. He had to have total commitment to his cause and to his comrades.

It was not easy to stay his course. It was not just the unknown future in facing death but the day-to-day trials that he now had to put up with. The guards were doing all sorts of things to annoy him and to try to put him off of his protest. They slammed doors all day to annoy him. They made sly comments. A prison governor came into Bobby's cell and saw that he was reading a book of short stories by Rudyard Kipling, a book that Bobby had dreamed about reading over the years when he was without any kind of reading materials.

"Ah, short stories, is it, Sands", said the Governor. "Well it's a good thing you're reading short stories because you won't be around long enough to finish a novel!"

This annoyed Bobby, even though he tried to ignore it. Tom McElwee who was a few cells away was ready to fight the Governor the next time he saw him.

Bobby also had to face the physical instinct to eat. Food still meant something to him. He complained about the dinner, pie and beans, and said that the beans were nearly falling off the plate.

"It was inviting (I'm human too)", he admitted, and he was glad to see it leave the cell. He joked about the temptation.

"Never would I have touched it, but it was a starving nuisance. Ha! My God, if it had have attacked, I'd have fled."

In place of food Bobby smoked some cigarettes. It was his last bad habit but, as he said, what was it going to do? Kill him? What it did do for him, as it had done for all of the blanketmen since they began their protest, was to raise his morale.

"We still defeat them in this sphere", he wrote in his diary. "If the Guards only knew the half of it; the ingenuity of the POW is something amazing.

The worse the situation the greater the ingenuity. Someday it may all be revealed."

By the time Bobby got around to writing in his diary that night, he was in a more generous mood and was beginning to get over his anger at the prison guards. He wrote to his comrade who got the smuggled diaries about how thankful he was for what the man and many others were doing to support him through this hardest of times. People did big and small things, he said, and he was just proud to have known so many people who he could call comrades and friends.

"I have always taken a lesson from something that was told me by a sound man", he wrote to his comrade. "Everyone, Republican or otherwise, has his own particular part to play. No part is too great or too small, no one is too old or too young to do something."

"So, venceremos, beidh bua againn la éigin. Sealadaigh abu."

["So, venceremos, we will be victorious someday. Up the Provos."]

Sunday 15th March 1981

F *rank has now joined me on the hunger-strike. I saw the boys at Mass today which I enjoyed...Again it was a pretty boring day.*

Sunday was still boring for Bobby, except for mass when he got to see lots of the other blanketmen. It was always great to see others. Francis Hughes had started his hunger strike. Now there were two of them on hunger strike. Even though Francie was far away in another H-Block it gave Bobby some encouragement that he was not alone.

When he got back from mass, he sat in his cell and tried to read. As usual he fell to thinking about how they had come to this point. They had done so much to move their protest forward over the years despite the harsh conditions in which they lived. They had done their best to change things for the better. Although it was very hard the prisoners had taken back control over their living spaces in the H-Blocks. It was a constant battle with the prison authorities but the men did everything they could to run their own lives and control what they did with their time. That was why it was so important to do the things that raised their spirits, like singing songs and, in Bobby's case, even writing songs and poetry.

But one problem with being in prison is that you cannot do much to change what is happening outside

the prison walls. Outside prison things were not so good. Some churchmen, including the Cardinal, had been trying to convince the British government to make some prison reforms. They told Margaret Thatcher, the British Prime Minister, that a few reforms could end all of the problems in the prison. All she had to do was to give the prisoners a few concessions, like letting them wear their own clothes instead of a prison uniform. But Maggie Thatcher refused to budge. When the Cardinal sent word back into the prison that Thatcher would not do anything to resolve the protest there was nothing left that the prisoners could do. They had nothing. Only one course of action was left and that was to go on a hunger strike.

Looking back, it was if everything they had done over the past few years had led to this point. The blanket protest led to the fights over visits and the searches where the guards hoped to find even a scrap of paper or a pen refill on a prisoner. Luckily they never found the radios on which some of the men now listened to the nightly news. Bobby even cheated a bit and listened to the folk music programmes on his radio. He used to tell his comrade Bik about the music it was listening to and it drove Bik crazy!

The violent searches led to the no-wash protest and before they knew it the men were living in filthy conditions that they would never have imagined living in just a few months before. And now, here

they were on hunger strike. Oh, there were people who tried to encourage the prisoners to think that maybe the political talks would lead to some kind of agreement. But Bobby had known all along that there was little hope of this happening. They had little hope of winning their protest, short of the hunger strike. The British government just would not budge.

So here he was. He didn't have much time in front of him. But he could still enjoy some things in life. He finally had some books and newspapers to read. How far he had come since his school days! Back then he would hardly pick up a book. All he wanted to do was play football. Now, the books gave him comfort. He loved to read and even the memory of books had carried them through the darkest days of their protest.

Now, as he lay back on his bed and slowly fell asleep he began thinking about tomorrow. He would have a visit with his family. It would be great to see them. And it would also mean that he would get a walk in the fresh air on his way to the visit. He remembered the story he once told the others about the condemned Frenchman who finally saw the cherry blossoms as though it was his first time. Actually it was his last.

God knows how many more times Bobby would be able to take a walk in the fresh air. It would tire him out. But he would relish it.

Monday 16th March 1981

There is a certain Screw here who has taken it upon himself to harass me to the very end and in a very vindictive childish manner. It does not worry me, the harassment, but his attitude aggravates me occasionally. It is one thing to torture, but quite a different thing to exact enjoyment from it, that's his type.

The hunger strike was starting to take its toll on Bobby. He was continually wrapped up in blankets, all but the one that he hung over the window to keep out the draughts. He found it especially hard to keep his feet warm. He was eating salt to keep his body strong, and drinking five or six pints of water a day. But whenever he took a drink of cold water it made him feel cold all over.

He was also starting to get bored with the books that were available to him. He kept asking his contact Liam Óg to send in books of his favourite poet, Eithne Carberry and he was even going to ask the authorities to bring him a dictionary because it would be more interesting to flick through it and learn new words than to read the books he had.

The newspapers were no better. There was nothing of interest to him in the English papers but, nonetheless, he would take a peek through them sometimes and hope that a screw didn't open

117

the door to see him reading an English paper and then make some kind of snide comment. The guards were always making comments these days, particularly one guy who seemed to get great pleasure from torturing Bobby. He tried to ignore it but sometimes it made him mad.

But Bobby did get one great joy. Someone smuggled in a copy of the previous week's An Phoblacht/Republican News, the Republican newspaper, and read it out through the door so that everyone could hear what was going on. Everyone enjoyed the 'war news', which told about what the IRA had done during the previous week. But there were also news items about the hunger strike and politics and it was a good way to keep up with what was going on outside the prison.

As he listened to his comrade reading out the news Bobby thought about his own role in the paper. For over three years he had been writing articles and poems for the paper. Sometimes, his stories appeared every week and it was through them that his penname, Marcella, became famous not just in Ireland but around the world.

The other prisoners called Bobby's writings the 'bible of the H-Blocks'. They told their story, including all the bad times and the good times, of which there were surprisingly plenty for a group of men living in such horrible conditions. He had

written stories about the barbed wire and the rats, about the beatings and the attempts by the prison authorities to break their spirits by blocking up the windows so that they could not see outside. But in all of these stories what showed through was the humanity. Bobby always wanted to show the world about how the blanketmen retained their dignity in the worst of times. After all, people would find it hard to believe that someone could keep their dignity when living in a dirty cell, with no furniture and pools of urine on the floor and their shit smeared on the walls. But Bobby showed how wrong they were.

In stories with titles like 'Alone and Condemned', 'A Break in the Monotony' and 'A Battle for Survival', Bobby wrote about how they could turn a terrible day into a good day by working together to raise each others' spirits.

The articles had been crucial too in showing the outside world what was happening in the H-Blocks. They helped build support among people outside. It was ironic that Bobby had done so much to build the campaign through all the letter-writing he organised and the articles he wrote and now here he was paying the ultimate price for that campaign. Here he was. Cold. Getting thinner by the day. He now weighed just 58 kilograms and felt like everything he did burnt up more of what little energy he had left. He went to his bed and tried to get warm.

Tuesday 17th March 1981

St. Patrick's Day. This was not like any other day for Bobby. It had been a special day ever since his first time in prison, back in the cages. It was a day for Irish. The Irish language had been so important to Bobby for a long time. He learned it with relish back in the cages. He and his friends, Tomboy and Séanna, were proud when they got their silver and gold fáinní, which showed the world that they could speak Irish fluently. He went with Tomboy to test for their gold fáinne and they met the Irish teachers outside the study hut where they were to take the test. They all fell into talking in Irish for a long time, arguing about sport and all sorts of other things. After a while, Bobby and Tomboy got impatient and one of them asked when they would be taking the test.

"You already took it. You passed", the Irish teacher told them.

Bobby tried to make the Irish language alive. He discussed with the other prisoners how they could improve their communities once they got out of prison. Bobby said that the best way to make things better would be to create new communities, with their own factories and shops, where everyone would speak Irish. He even began to write about it in the old Irish script that his

teachers used.

It was one St. Patrick's Day that he began to think about how important it was to use the Irish language every day. He thought about the Irish TV and radio stations. They only used Irish on St. Patrick's Day. Then they went back to speaking English for the rest of the year. It made Bobby angry. He had noticed that even the Welsh used their native language more than the Irish seemed to, at least on TV and radio. He wrote about it in the prison newspaper. It was one of the first articles he ever had published and it was in Irish.

"We need Irish on television", he wrote, "maybe it will help everyone learn Irish and then maybe we'll have St. Patrick's Day everyday. I hope so."

Well, they still did not have much Irish language on the Irish television, although Bobby had not seen much television for quite a few years. But that had not stopped Bobby from trying to make his dream a reality. Here in the H-Blocks, they had nothing but their own initiative. But with that nothing they had created an Irish-speaking community where most of the blanketmen spoke Irish every day. Only a handful had spoken it when Bobby was first sent to the H-Blocks. Now hundreds of them spoke Irish. And one day they

would leave prison and they would start Irish schools in their communities, along with Irish newspapers, radio stations, shops and cultural centres. Bobby would never see it. But it gave him some satisfaction. It was a legacy he could be proud of.

He sat down and wrote the last entry he would write in his diary. It was in Irish.

Lá Pádraig inniú 's mar is gnách níor thárla aon rud suntasach, bhí mé ar aifreann agus mo chuid gruaige gearrtha agam níos gaire, agus é i bhfad níos fearr freisin. Sagart nach raibh ar mo aithne abhí ag rá ran aifreann.

Bhí na giollaí ag tabhairt an bhia amach do chách abhí ag teacht ar ais ón aifreann. Rinneadh iarracht chun tabhairt pláta bidh domhsa. Cuireadh ós cómhair m'aghaidh ach shiúl mé ar mo shlí mar is nach raibh aon duine ann.

Fuair mé cúpla nuachtán inniú agus mar shaghas malairt bhí an Nuacht na hEireann ann. Táim ag fáil pé an scéal atá le fáil óna buachaillí cibé ar bith.

Choniac mé ceann dona dochtúirí ar maidun agus é gan béasaí. Cuireann sé tuirse ormsa. Bhí mo chuid meachain 57.50 kgs. Ní raibh aon ghearán agam.

Bhí oifigcach isteach liom agus thug sé beagán íde béil domhsa. Arsa sé 'tchim go bhfuil tú ag

léigheadh leabhar gairid. Rudmaith nach leabhar fada é mar ní chrlochnóidh tú é'.

Sin an saghas daoine atá iontu. Ploid orthu. Is cuma liom. Lá fadálach ab ea é. Bhí mé ag smaoineamh inniú ar an chéalacán seo. Deireann daoine a lán faoin chorp ach ní chuireann muinín sa chorp ar bith. Measaim ceart go leor go bhfuil saghas troda.

An dtús ní ghlacann leis an chorp an easpaidh bidh, is fulaingíonn sé ón chathú bith, is greithe airithe eile a bhíonn ag síorchlipeadh an choirp. Troideann an corp ar ais ceart go leor, ach deireadh an lae; téann achan rud ar ais chuig an phríomhrud, is é sin an mheabhair.

Is é an mheabhair an rud is tábhachtaí. Mura bhfuil meabhair láidir agat chun cur in aghaidh le achan rud, ní mhairfidh. Ní bheadh aon sprid troda agat. Is ansin cen áit as a dtigeann an mheabhair cheart seo. B'fhéidir as an fhonn saoirse.

Ní hé cinnte gurb é an áit as a dtigeann sé. Mura bhfuil siad in inmhe an fonn saoirse a scriosadh, ní bheadh siad in inmhe tú féin a bhriseadh. Ní bhrisfidh siad mé mar tá an fonn saoirse, agus saoirse mhuintir na hEireann i mo chroí.

Tiocfaidh lá éigin nuair a bheidh an fonn saoirse seo le taispeáint ag daoine go léir na hEireann ansin tchífidh muid éirí na gealaí.

Learn Irish and you will know what Bobby wrote in his last entry of his diary. This much we will let you know. He ends with the following words, which more or less sum up what his life was all about:

'If they aren't able to destroy the desire for freedom, they won't break you. They won't break me because the desire for freedom, and the freedom of the Irish people, is in my heart. The day will dawn when all the people of Ireland will have the desire for freedom to show.

'It is then we'll see the rising of the moon.'

On Monday, March 23, the authorities moved Bobby to the prison hospital, where he would remain for the rest of his life. From there, he helped run an election campaign that ended when the Irish people of counties Fermanagh and Tyrone elected him to British parliament. This did not move Margaret Thatcher or others in the British government. They continued to refuse any reforms of conditions in the H-Blocks of Long Kesh.

Bobby's comrades never saw him again. He was comforted at the end when the prison authorities let his family visit him. He had a last request for his mother. He asked her to let him die. It was the hardest thing you could ask your mother. But she honoured Bobby's last request. His family stayed with him at the end.

On May 5, after sixty-six days on hunger strike, Bobby Sands died. His last words were for his family.

'I love you all. You are the best mother in the world. You stood by me.'

Hundreds of thousands of people came onto the streets to mourn Bobby Sands. Parliaments around the world had moments of silence in his honour. Nelson Mandela and his comrades on Robben Island in South Africa followed him onto hunger strike to win rights for South

African political prisoners. Others later did likewise, in Mexico, Turkey and other countries around the world.

Nine more blanketmen followed Bobby Sands to their deaths on the hunger strike, which lasted all through the summer of 1981.

Francis Hughes, Bellaghy, Co Derry, died 12 May after 59 days.

Raymond McCreesh, Camlough, Co Armagh, died 21 May after 61 days

Patsy O'Hara, Derry city, died 21 May after 61 days.

Joe McDonnell, Lenadoon, Belfast, died 8 July after 61 days.

Martin Hurson, Cappagh, Co Tyrone, died 13 July after 46 days.

Kevin Lynch, Dungiven, Co Derry, died 1 August after 71 days.

Kieran Doherty, Andersonstown, Belfast, died 2 August after 73 days

Tom McElwee, Bellaghy, Co Derry, died 8 August after 62 days.

Mickey Devine, Derry city, died 20 August after 60 days.

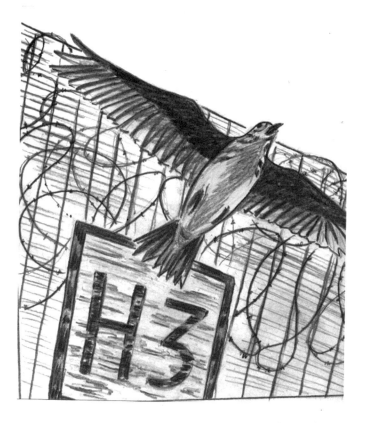

Irish Republicans hold the hunger strikers in the highest regard, for the lives they led and the sacrifices they made for Irish freedom.